PERSPECTIVE

FOR THE BEGINNING ARTIST

More than 40 techniques for understanding
the principles of perspective

by Mercedes Braunstein

Tools & Materials, 4

Con

Techniques, 18

tents

Subjects, 68

Tools & Materials

An artist needs very few materials for drawing, and they are all very easy to use. The tools and materials used throughout this book are described in the following pages, including graphite pencils, colored pencils, charcoal, sanguine, chalk, pastels, and ink, as well as the various techniques and the best type of paper to use with each one. However, when beginning a perspective drawing, it is best to plan out the drawing on sketch paper before starting on the final drawing.

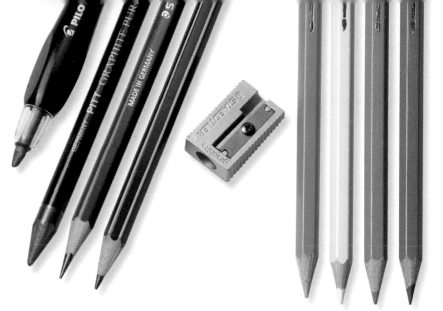

All you need to draw are two graphite pencils: a hard lead to sketch and a softer lead for shading and drawing more intense, energetic lines. It's also important to have a pencil sharpener, as you will need to sharpen your pencils frequently. Another option, of course, is to use refillable, mechanical pencils.

Pencils

This very common drawing tool consists of a graphite or colored lead core encased in a wooden shell. A graphite pencil is used to trace and shade, while colored pencils are used to add color to a drawing.

GRAPHITE PENCILS

Graphite creates dark, gray-colored lines; the specific characteristics depend on the hardness of the lead and the sharpness of the point. With a harder lead, the lines will be thinner and lighter. With a softer lead, the lines will be darker and thicker. Generally, artists tend to use pencils with softer lead for more intense lines. To find out how hard or soft the lead is within a graphite pencil, look for the number and letter that appear at the end of the shaft. An H stands for hard lead, B stands for soft, and HB means an intermediate level of hardness. The best pencil to use to begin a drawing is usually a 2HB—this pencil uses light, muted lines that are easy to correct or erase without leaving any marks. Afterward, you can use a softer pencil (such as a 4B) to shade in the drawing.

COLORED PENCILS

There's no doubt that having a wide range of different colored pencils will make the job easier for any artist. The colored core allows you to apply color directly without having to think about mixing colors. You can create different tones by overlapping colors; however, the hard lead makes it difficult to create intense shades. There are types of colored pencil that have softer lead that can be diluted with water. This softer core produces more vibrant colors and makes sketching easier.

It is very easy to create a range of different shading tones with pencil. Produce more intense tones by pressing the lead harder against the paper or by layering lines on top of each other.
A With graphite pencil, you can create different shades in a tonal range.
B You can also use colored pencil to produce a range of different tones.

The fine line above was drawn with a hard graphite pencil; the second was drawn with a soft graphite pencil; and the third was drawn with a graphite bar.

A

B

Charcoal is generally used on white paper. However, drawing on colored paper can create a different contrast, producing an attractive, more vibrant result.

Charcoal

Charcoal is a classic tool used for drawing. Charcoal varieties include vine charcoal, charcoal pencils, or compressed charcoal sticks. It's a good idea to get familiar with the characteristics of all three types of charcoal. The major appeal of this medium for artistic drawing is the ease with which it allows you to create rich tonal ranges by smudging and fading, which gives the drawing a significant sense of volume.

CHARCOAL STICKS

Though fragile, charcoal sticks allow you to create a very broad range of tones. Charcoal can be blurred by rubbing a cotton cloth over the lines, almost to the point of erasing them, which allows you to correct and model the drawing as you work.

CHARCOAL PENCILS

Charcoal pencils are quite hard and somewhat oily. These are great drawing tools that allow you to draw fine lines without running the risk of breaking the pencil tip. They are less volatile than charcoal sticks, and they produce lines that do not erase easily.

The materials used to create charcoal drawings typically include a couple of vine charcoal sticks of different thicknesses and a compressed charcoal stick, as well as a cotton cloth for smudging and a charcoal eraser, which is very useful for completely erasing light lines.

COMPRESSED CHARCOAL STICKS

Compressed charcoal sticks are much stronger than vine charcoal sticks. Although they produce lines that cannot be erased, their very intense black color can expand the tonal range of the drawing.

Charcoal sticks allow you to create a diverse range of tones. Each value can be further smudged with the index finger to create a lighter, even shade. You can also shade more easily than with graphite, as you can create several different tonal values, including drawn values and smudged values.

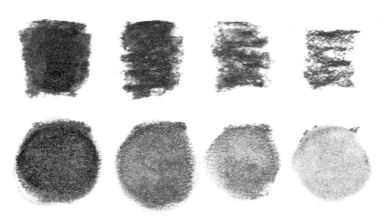

These lines were drawn with charcoals of different thicknesses.

Sanguine

Sanguine chalk is characterized by its reddish color in both stick and pencil form. Although its core is harder than charcoal sticks, sanguine also allows you to create a rich tonal range with delicate values and shading.

CHARACTERISTICS OF SANGUINE STICKS

Reddish colored sanguine sticks are slim, quite resistant, and make it easy to draw fine edges. In order to fill a broad area of the drawing, use the edge of the stick. Sanguine does not erase easily; for this reason, draw the first strokes very lightly to avoid mistakes.

CHARACTERISTICS OF SANGUINE PENCILS

When surrounded by a wooden casing, a core of sanguine chalk is harder than a sanguine stick. However, both can be used together in the same drawing for variety. The pencils are easy to handle and allow you to draw fine lines quite easily.

SEPIA

Sepia, in stick or pencil form, has a darker color than sanguine. Some artists create an entire drawing in sepia. In other drawings, sanguine and sepia complement each other with excellent contrast, expanding the tonal range of the drawing by using them together.

DRAWING WITH TROIS CRAYONS

The trois crayons drawing technique combines charcoal sticks, sanguine, and white chalk in the same drawing. The charcoal and sanguine are mixed together to obtain rich, dark tonal ranges, and the white chalk is used to create highlights, adding contrast to the drawing.

To produce fine lines, you can use a sanguine pencil, as well as the edge of a sanguine stick. To draw a thick stroke, break the stick in half and press it against the paper.

For a complete pencil drawing using the trois crayons technique, you should use sanguine, sepia, white chalk, and charcoal.

A It's easy to create different values. All you have to do is press a piece of the chalk onto the paper and apply more and more pressure, creating a more intense shade.

B Hatching is a collection of strokes that overlap each other to obtain darker values. These strokes are drawn in different directions and overlap each other.

It's extremely easy to create a range of tones with a sanguine stick; all you have to do is press down harder and harder to produce more intense shades.

A

B

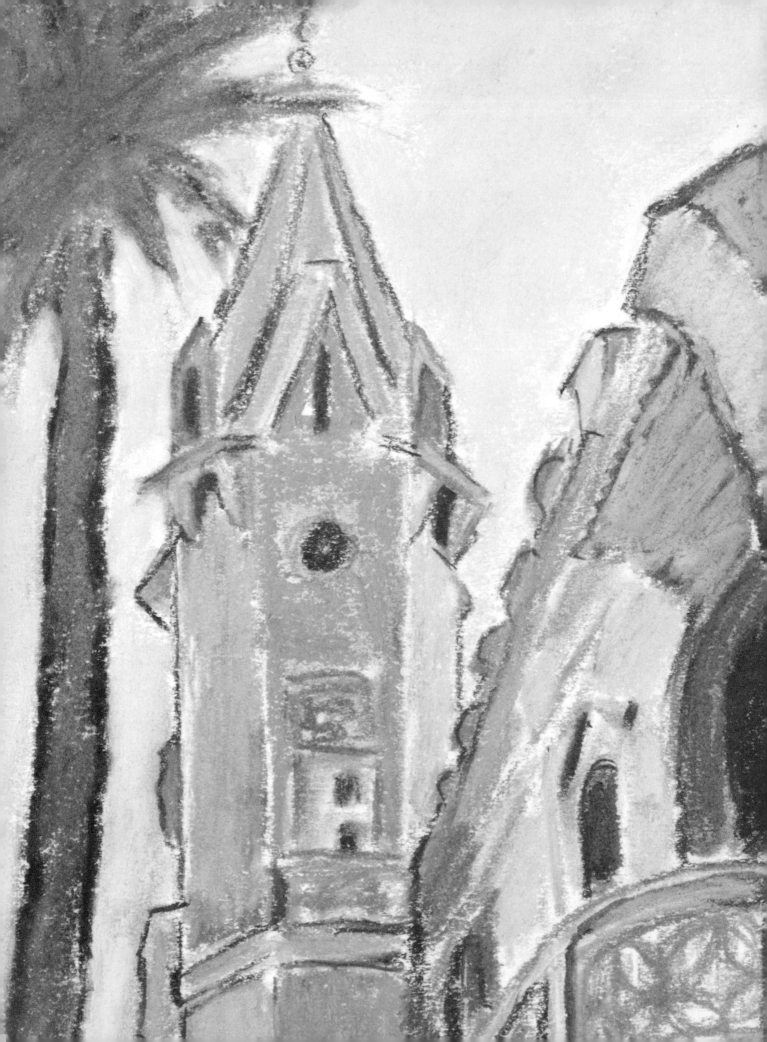

Pastels, especially soft pastels, are a true explosion of color.

Chalks & Pastels

CHALKS

Chalks usually appear as small, square-shaped sticks. Like pastels, they contain pigment; however, chalks contain less of it. Because they are harder than pastels, you can draw the initial sketch and the preparatory lines of a drawing with chalk.

PASTELS

Pastels create a true explosion of color. They are made up of almost pure pigment, creating lovely, vivid drawings. Pastels are very fragile and tend to break easily. Each individual stick should be properly stored in some kind of supply box.

PASTEL PENCILS

Pastel pencils are commonly used for the first lines of a sketch; they should be used lightly, with very little pressure on the paper. Some drawings are done using only pastel pencils, with tracing, coloring, or hatching. However, the fine strokes of pastel pencils can also complement a drawing made with pastels.

TONAL RANGES, SMUDGES, AND SHADING

Pastels allow you to create tonal ranges very easily by adding more pressure against the paper with the stick to create a more intense value. Shading connects an entire tonal range together, moving from the lightest to the darkest value gradually, or vice versa. You can modify the look of the shade by smudging the color on the paper. Use the tip of your index finger (or another part of your hand) to press down on the color, using a circular motion. Pastels can also achieve volume and within a drawing, as they are an ideal media to represent depth.

Pastels allow you to create colorful tonal ranges that can be smudged with your index finger, by pressing down and moving in a circular motion.

A

B

Λ These values are the result of pressing the pastel stick down, lightly at first, and then progressively with more and more pressure.

B You can also smudge a value, modifying its effect.

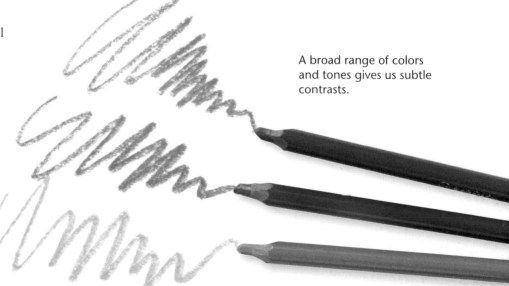

A broad range of colors and tones gives us subtle contrasts.

The only tools you need to draw or paint with ink are a nib mounted on a handle, a brush, and blotting paper.

Ink

INDIA INK

This is an ancient material that, once dried, cannot be erased or diluted. In order to draw with ink, prepare your sketch in advance with a light pencil sketch. Then use a pen nib or brush to apply the ink. Wait until the ink is fully dry to erase the original pencil sketch marks.

COLORED INK

There are various colors of ink; however, only some of them are permanent. Apply the colors separately, and every time you switch colors, be sure to keep your nib or brush extremely clean. It's a good idea to apply each color to closed-off areas that aren't touching any other colors. Then wait until the rest of the drawing is completely dry before applying a new color.

Varied tones can be created by hatching with a pen nib. Styles of hatching can vary a great deal, and you must apply them deliberately to create accurate perspective.

NIBS

Nibs are available in different thicknesses. Some are more rigid and draw in a straight, uniform fashion. Others are more malleable and make it possible to draw with artistic, stylized strokes. Nibs must be loaded with ink from the inkwell frequently, but be careful to avoid accidentally dripping ink onto the drawing.

BAMBOO BRUSHES

While less common than nibs or brushes, bamboo brushes are the perfect natural tool to create large-scale drawings.

BRUSHES AND WASHES

A wash makes it possible to produce different tones by diluting the ink with water. As you work, first apply the lightest shade of wash, and then progressively incorporate darker washes. Make sure to let the work dry before applying a new layer of wash.

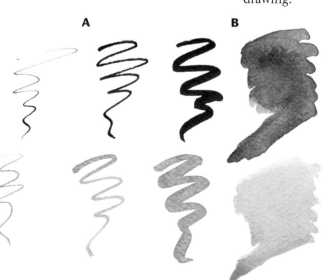

A A fine-tipped nib is used for details or for small drawings. Using thin and thick nibs on the same drawing allows you to distinguish different layers of the scene; try drawing the foreground with a thick nib and the background with a thin one.

B Brushstrokes with pure ink are very intense. The more water you add, the lighter they will be.

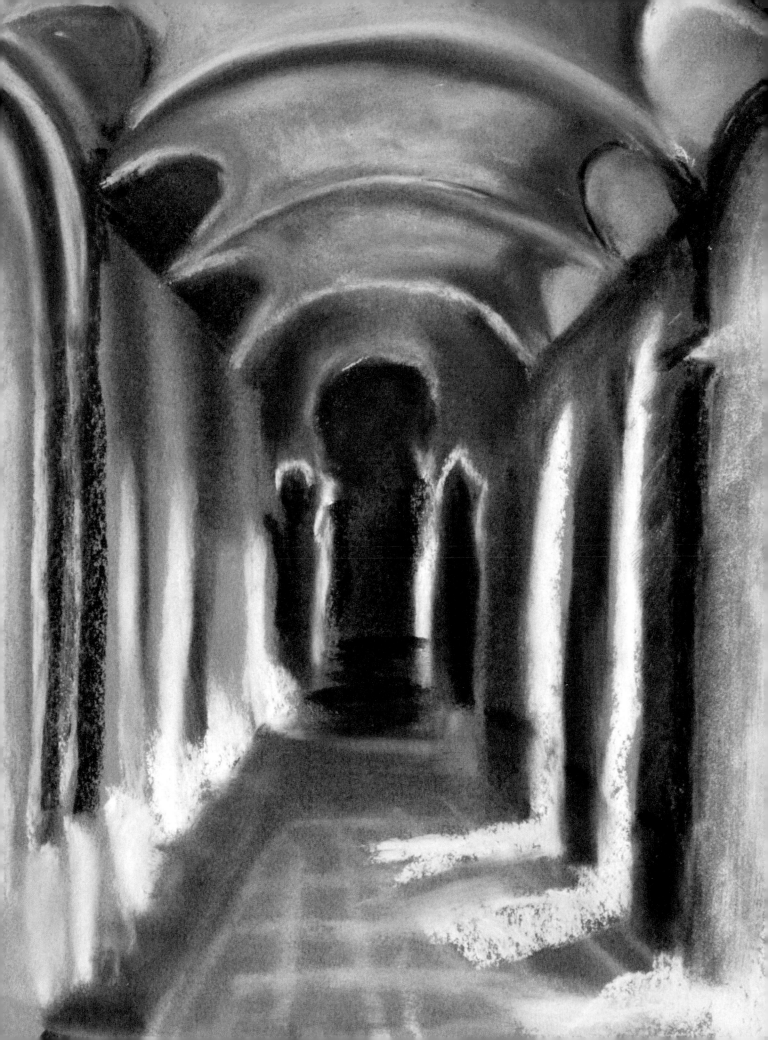

Paper

One important characteristic of drawing paper is the texture of the paper's surface. It may have a glossy or rough finish. The weight of the paper indicates its thickness. It is also good to know how absorbent the paper is, as it will react differently if you use a dry or wet medium on it. Finally, you will have to pick the right color paper, as there are several options available. Let's take a look at the best characteristics of paper for each medium.

The paper for graphite and colored pencils should have a very light grain.

▲ Most papers for drawing with charcoal, sanguine, chalk, and pastels have a different texture on each side. Colors will have a more subtle finish on the finer side of the paper.

▼ You can use the same type of paper for charcoal, sanguine, chalk, and pastels. In the beginning, it's best to use white paper; later on, you can try using colored paper, with cold or warm tones for contrast.

PAPER FOR DRY MEDIA

Many types of paper, due to their particular characteristics, are suitable for dry media: charcoal, sanguine, chalk, and pastels. Some papers are fine and others are full-bodied. Generally speaking, however, all of them have a double texture: one side has a rough grain and the other a fine grain. Even the color will have a different look, depending on which side of the paper you draw.

PAPER TO USE WITH INK

When drawing with a pen nib, the paper should allow you to draw with ease. It should not have a grain, but if it does, it should be a very fine grain. Ink paper tends not to be the best for washes, as washes require absorbent paper. However, if you want to use brushes and pen nibs on the same drawing, it's a good idea to use watercolor paper with a satin finish.

PAPER FOR DRAWING WITH GRAPHITE AND COLORED PENCILS

Many papers are suitable for both graphite and colored pencils. Both have a certain saturation point in relation to the paper. In other words, there will come a point when you can't create a more intense tone, no matter how much you keep drawing or coloring. In order to manage this saturation point, it's a good idea to apply layers gradually.

▼ If you want to use both pen and brush ink techniques on the same drawing, you can use watercolor paper, as this paper allows you to work with a pen nib. Although it is generally a good idea to use white paper, you can enrich your ink drawing if you choose paper with a very light color.

Techniques

It's possible to learn drawing techniques in a variety of ways. In this book, we use very simple, effective methods to represent the easiest perspectives—*frontal view* and *oblique view*—using a combination lines and curves. Both of these perspectives will prepare you for a third, more complex perspective: *aerial view*. In this first section, we focus on the importance of drawing very basic sketches. This will help you draw horizontal and vertical lines, as well as other important directional cues, such as vanishing lines. Based on these sketches, you will create line drawings with specific contours, which you will continue to enrich by adding highlights and shadows to them. With shading, coloring, and fading, you will give more depth to your drawing, creating a greater sense of volume.

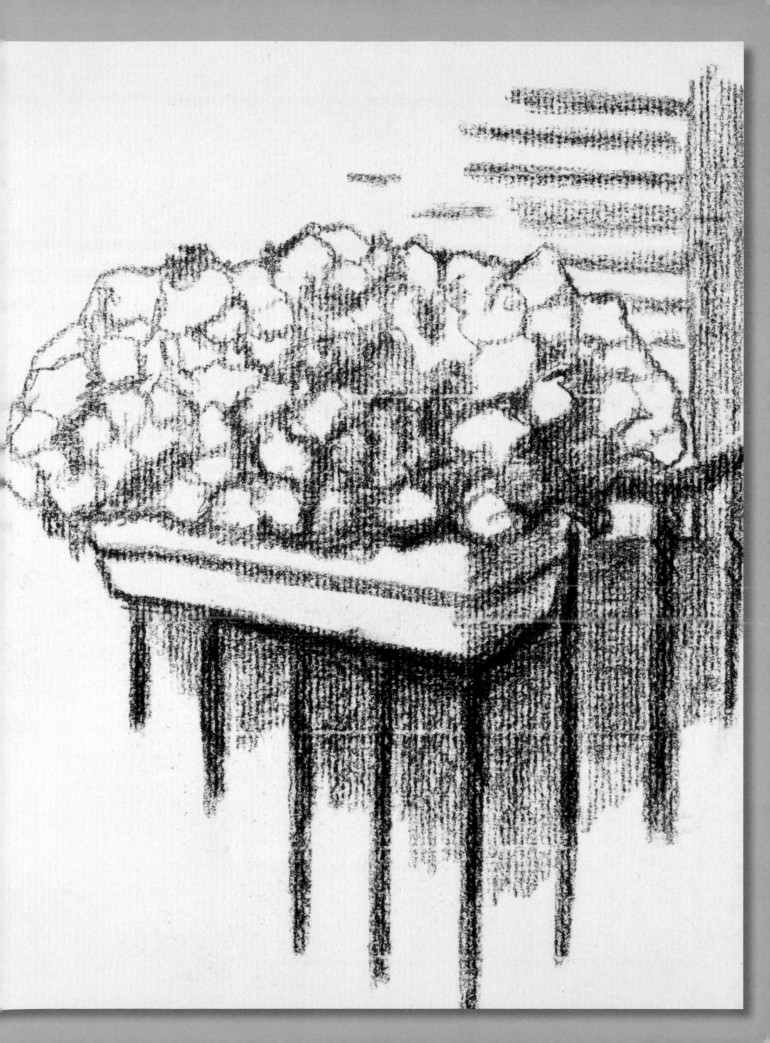

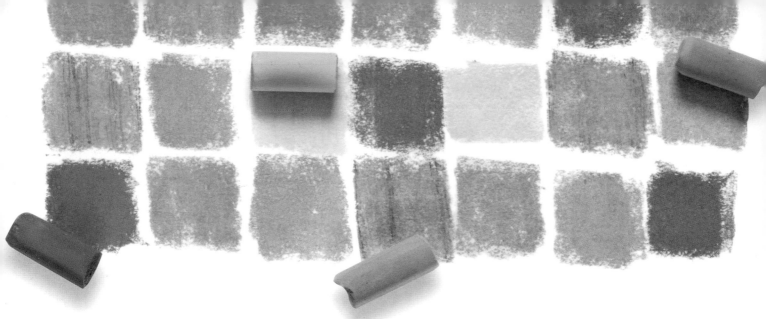

The Sketch

Before drawing the subject in perspective, pay close attention to it. Every subject has a characteristic shape and symmetry. Pay attention to the subject's silhouette, and select the simple shape or the combination of simple shapes that make it up. To draw these figures, compare the measurements of the subject and look at their simple, evident proportions. With points and lines, based on simple shapes, you can easily draw the frontal view of a flat subject. By getting to know the characteristics of your subject, you will be able to represent it with perspective later on, feasibly and easily, based on the simple shapes from your sketch.

▲ A simple mosaic on a wall viewed from a direct frontal perspective is an example of how a square, one of the basic shapes, represents each piece perfectly. While the composition is very simple, it is also richly colored. It is easy to draw, using nothing more than broken sticks of chalk.

1 If you add a half circumference to the upper part of a square shape, you have a basic sketch of a two-wing door. This simple sketch combines two basic shapes: a square and a circle. Using just your pencil and paper, you can immediately sketch the basic shape of the door, as seen from a direct frontal angle. To practice your lines, it's a good idea to start off with basic sketch paper.

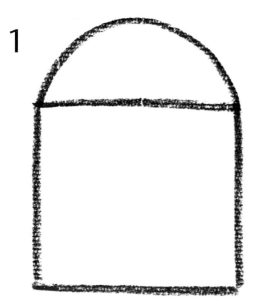

1

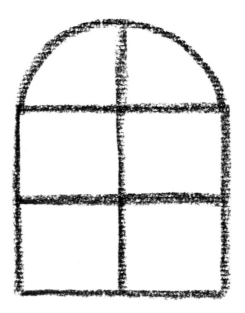

2

2 Divide the space occupied by the window with simple proportions that won't require you to measure anything exactly. In this case, the height is divided into three parts.

3

3 Apply more details to the initial sketch, to make the door recognizable. Parallel lines—both vertical and horizontal—and perpendicular lines, or right angles, are very useful. Basic shapes are also used to develop the subject's characteristics, given the fact that many windowpanes are square-shaped. The double partitions are quite easy to draw. Draw the interior frame by following the guidelines of the outer frame. Now all you need are a few more details to have a well-defined double door.

4 Draw the initial sketch onto your final paper with gray chalk and color it with a sepia pencil. The gray chalk will contrast nicely with the sepia and enrich the drawing with texture.

4

DO

Practice drawing curved and straight lines vertically, horizontally, and perpendicularly.

DON'T

Draw intense lines until you feel fully confident about their direction and size.

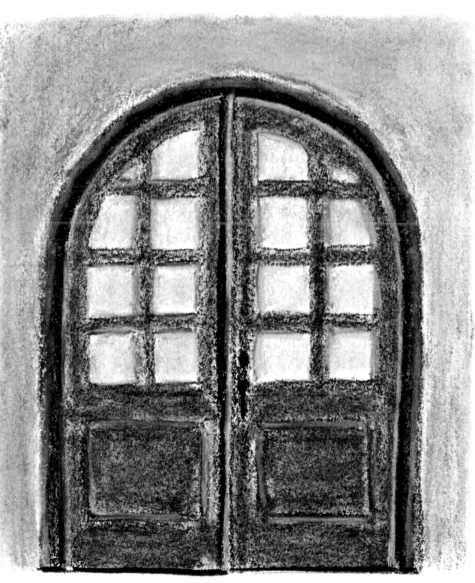

Frontal Perspective

This example shows a very easy-to-draw frontal view, and it emphasizes an important point. When we are directly in front of an object with parallel lines that appear horizontal, the lines should be drawn horizontally as well. The same thing applies to the vertical parallel lines of the subject, which appear vertical in frontal view. If you start a sketch with just a few lines and simple curves, you will be able to draw the sample without much trouble.

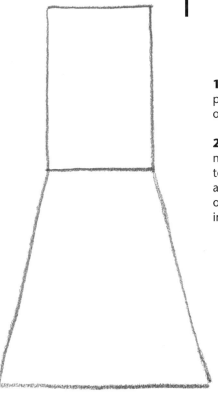

1 Draw the basic drawing on sketch paper. This first drawing is made up of basic, simple shapes.

2 The sketch should note the simple measurements that will allow you to draw both parts of the subject and depict their relationship to each other. The marks inside the rectangle indicate the location of the door.

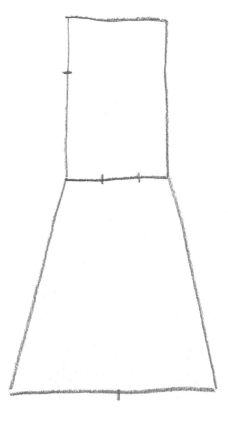

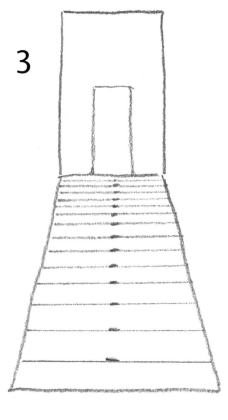

3 After transferring the basic sketch to your final paper, draw a rectangle inside the upper rectangle to represent the door. Underneath it, draw several parallel horizontal lines, taking care not to go outside of the sketched box. The distance between the first two steps at the base of the staircase is the greatest, as they are closest to you. The parallel lines should then get progressively closer to each other the farther up you go.

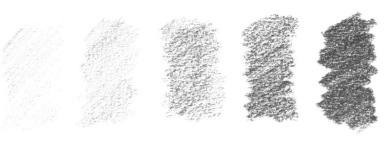

4

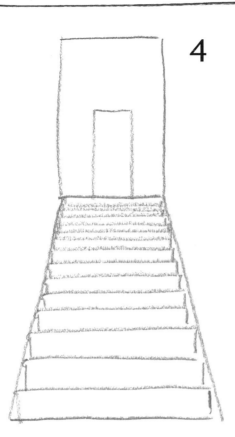

▲ A graphite pencil will allow you to create a tonal range with several different values. All you need to do is shade over the same area multiple times, or press down harder to obtain darker shades.

5

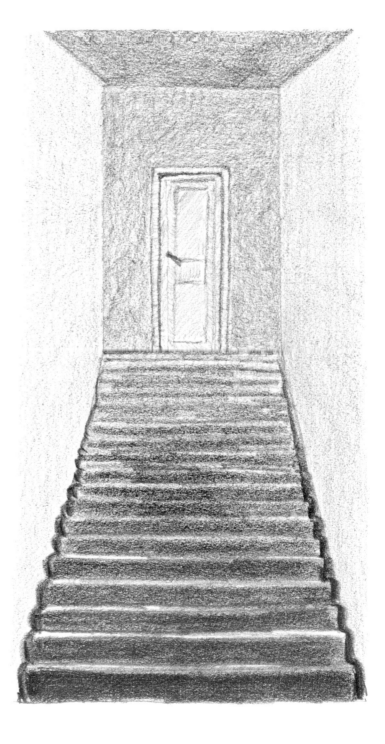

4 Draw a second series of parallel lines, making them vertical this time, on the outer edges of each horizontal line. These represent the steps. Little by little, your drawing is coming together. It's a piece of cake!

5 Now you can add shading to give your drawing depth. There should be more contrast between tones in the foreground, and this contrast should decrease and lighten progressively with distance.

DO

Remember that this drawing is a great example of how horizontal and vertical lines should be kept parallel in a frontal perspective drawing.

DON'T

Make the drawing too small, as you want the relative size of each element to be clearly visible.

Buildings tend to have a regular shape, such as a cube or a rectangle. In order to set up the basic sketch when drawing a building, you first need to draw the horizon line, which is the line indicating the horizontal plane. The horizontal line should be placed at the level of the observer's point of view on the vertical plane of the background, also called the infinity point. On this line, place the vanishing point from the frontal view; this is the point where all the lines that cross through the drawing converge on the horizon line. The frontal view allows you to see the front of a subject, as well as some of the subject's top or side. In both instances, it is easy to create a basic sketch.

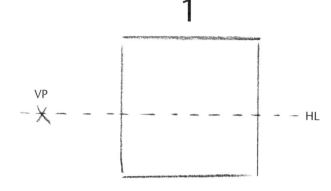

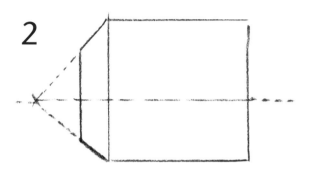

Frontal View

1 First draw a square, locating the horizon line (HL) and the vanishing point (VP).

2 Then draw the vanishing lines and establish the side view.

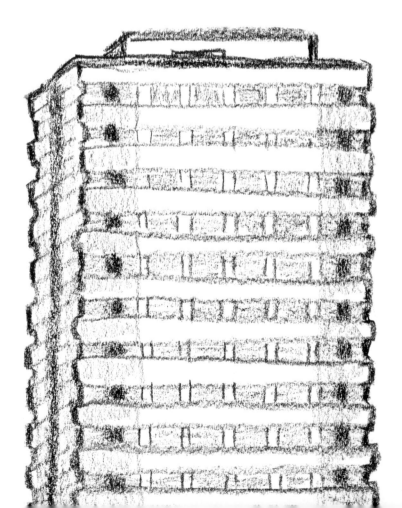

Tip
Use a sheet of sketch paper to draw the first sketches. Start by drawing small distances. Try to draw the parallel lines freehand, as the drawing will look more artistic this way.

◄ A building seen from frontal view, with a view of part of its side.

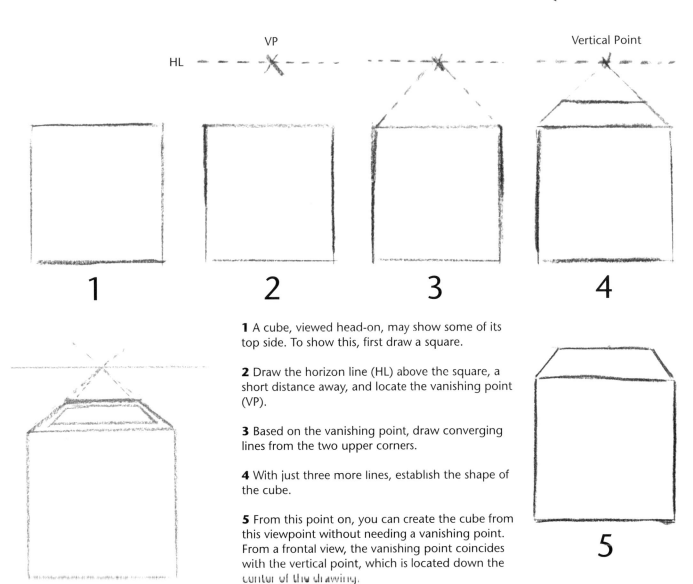

HL ---- VP ---- Vertical Point

1 2 3 4

1 A cube, viewed head-on, may show some of its top side. To show this, first draw a square.

2 Draw the horizon line (HL) above the square, a short distance away, and locate the vanishing point (VP).

3 Based on the vanishing point, draw converging lines from the two upper corners.

4 With just three more lines, establish the shape of the cube.

5 From this point on, you can create the cube from this viewpoint without needing a vanishing point. From a frontal view, the vanishing point coincides with the vertical point, which is located down the center of the drawing.

5

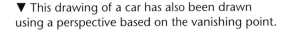

▲ The inner square is also measured and drawn by making sure the lines converge at the vanishing point.

▼ This drawing of a car has also been drawn using a perspective based on the vanishing point.

▲ This drawing represents a building viewed from a frontal viewpoint; however, part of its roof is visible as well.

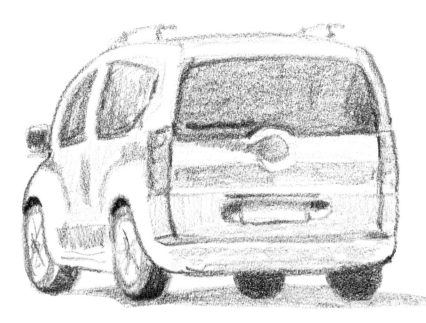

By definition, the top and bottom of a cylinder are circular bases. However, when neither the top nor the bottom is visible, you'll see that while the sketch might look like a simple rectangle, its shape is made up of two vertical lines connected by two curves, one concave and one convex. On the other hand, when you can see the top of the cylinder, the circle looks flattened, and a similar curve is seen on the bottom as well, if the object is not too tall.

◀ Sketch of a tall cylindrical shape, viewed from the front.

▶ If you use slightly different coloring for each part of the subject, you will increase the sense of depth, even from a completely frontal view.

Circles & Cylinders

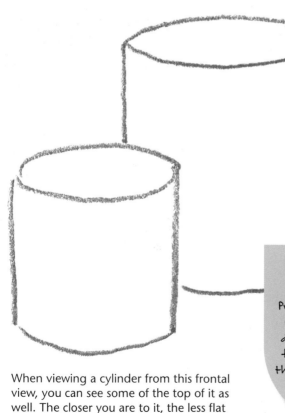

When viewing a cylinder from this frontal view, you can see some of the top of it as well. The closer you are to it, the less flat the circle will appear; the farther you are from it, the flatter it will appear.

Tip
Practice drawing circles using perspective. First draw them smaller and flatter, and then draw them bigger and rounder.

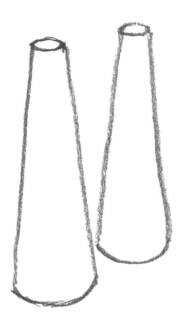

Even if the shape is a cone, rather than a cylinder, the same rule applies. The opening of this vase looks like a flattened circle, and the bottom is drawn with a curved line.

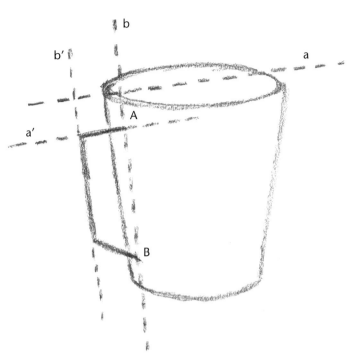

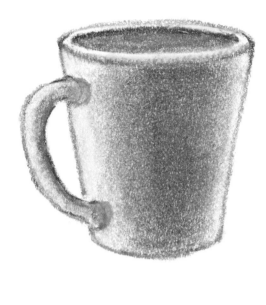

Most objects have elements that complement their basic shape. For instance, in order to draw the handle of a mug, first locate the plane (defined by lines a and b) that divides the mug into two halves. Locate the connecting points (A and B) and the respective parallel lines (a' and b') to help you with this.

Once you understand how to represent a mug with a handle (seen from a side view), you will be able to easily draw and color it on your final paper, using the appropriate shading to give it a sense of depth.

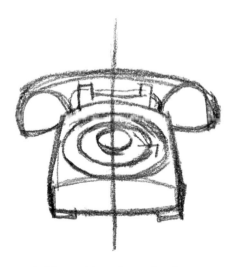

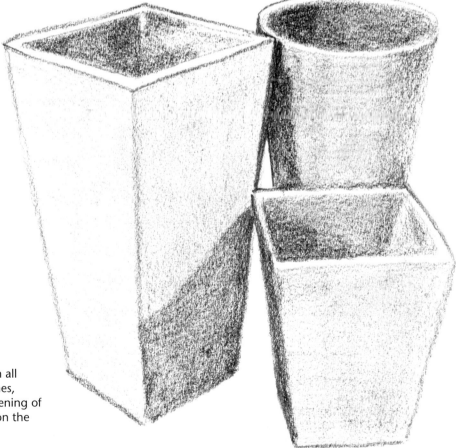

▲ Many objects have circular elements to them, and when drawn in perspective, the circular parts appear as flattened circles, like the rotary dial of this telephone.

► Still life compositions contain objects with all sorts of different shapes. To draw their outlines, draw curved lines on the base and at the opening of the circular objects, and draw straight lines on the objects with flat surfaces.

Spheres

A sphere is a perfectly shaped object. If it is smooth with no details, it will look like a circle—only light and shadow give it volume. If there are any details on the sphere, however, such as lines or colors that break up its surface, those details must be represented using perspective. First, draw a sphere; then incorporate a flat, horizontal circle based on the diameter (to create a half sphere). To do this, all you have to do is draw a flattened circle. Learning to draw the different sections of a sphere can be very useful for drawing balls, lamps, umbrellas, etc.

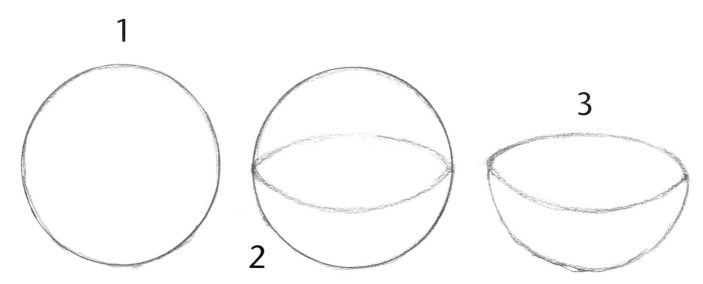

1 A flat circle can represent a sphere.

2 Another circle—this one is flattened—allows you to give a greater sense of volume.

3 To draw a simple sketch of a half-sphere (such as half of an orange), all you need to do is erase the upper arch.

Tip
Don't color or shade an object in any random direction. Follow the direction of the arches or perpendicular lines.

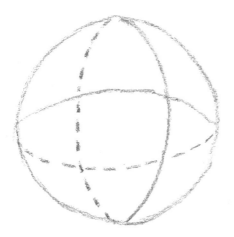 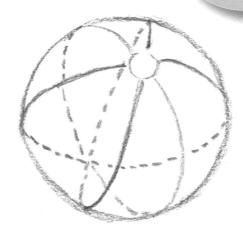

To draw the different sections of a sphere, you will need to imagine the circumference lines around the parts of the circle that are not visible. This will allow you to understand their origin points and tilt.

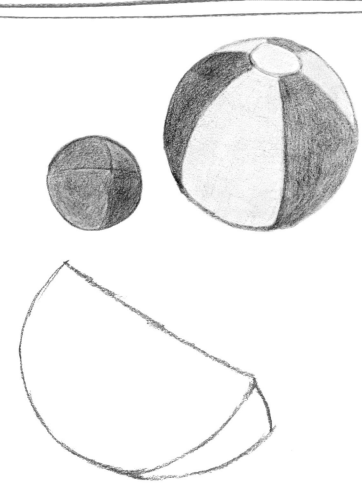

Draw the main lines that separate the sections around the sphere, following the direction of these arches. This increases the sense of volume.

This simple sketch of a slice of watermelon is quite easy to draw. It becomes simple once we associate it with the sphere it was once a part of.

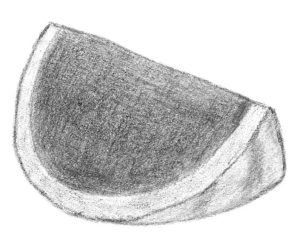

Layer by layer, apply color until you create the desired level of intensity. Just as shown in the drawing, the direction of your strokes should follow the shape of the object.

Most still life compositions with fruit contain elements that are made up spheres, such as cherries and apples; half-spheres, such as half of an orange; or even sections of a sphere, such as a slice of watermelon.

Oblique View

Regularly shaped objects with flat surfaces are often viewed with one corner or edge visible. This is considered an oblique view. You will sketch these objects based on the visible corner or edge, first locating the horizon line and the two vanishing points. Extend the vanishing lines from the structure and a few more lines to mark additional measurements and details. Two examples are provided here. In both instances, the relationship between their sizes is quite simple, and you will be able to sketch the subjects quite easily.

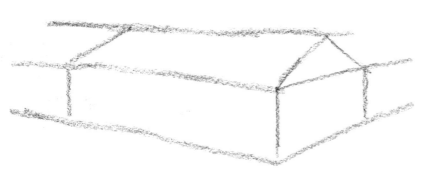

◄ It is easy to locate the roof, using an elongated shape and an oblique perspective.

▼ Draw this sketch of an inn, viewed from an oblique perspective. Base the sketch on a shape longer than a cube, and use the same vanishing points to represent the roof.

VP1 VP2

HL

C

a b

c

d

This cube with three visible sides is the reference
point for drawing the "inn" above. Draw the
horizon line, locating both vanishing points, and
beneath it, without centering, draw the frontal
vertical corner. Extend lines toward the vanishing
points: a, b, c, and d. Mark and draw the other
vertical corners as well. Finally, draw two vanishing
lines beginning at a and b that cross through point
C, which will determine the rest of the cube.

Tip

Practice drawing various
everyday objects from
an oblique perspective,
trying out different
points of view.

▶ To draw this coffee
grinder, you must
adapt the rules of
drawing a cube from
an oblique perspective
with some shapes that
are characteristic of
the subject.

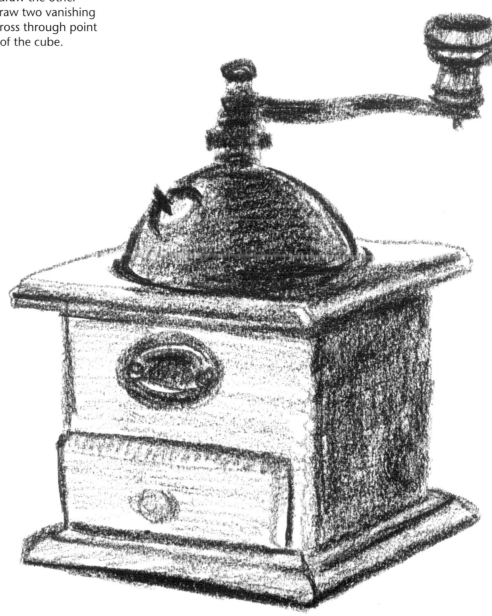

Practicing Perspective

The oblique view can be applied to a drawing in a simplified form. For the general sketch, one vanishing point is often enough. However, in order to better depict the characteristics of the subject, you will have to study some of its elements using two vanishing points. In separate sketches, sketch and draw out the basic form, the additional details in the sketch, and then the final drawing. There are not many lines at all, but they should describe the vanishing points quite well.

▼ Beginning at the height of the closest post, using only one vanishing point (VP1), draw the general sketch. If you compare the total height and width of the subject, you will see that the width is almost two times the height.

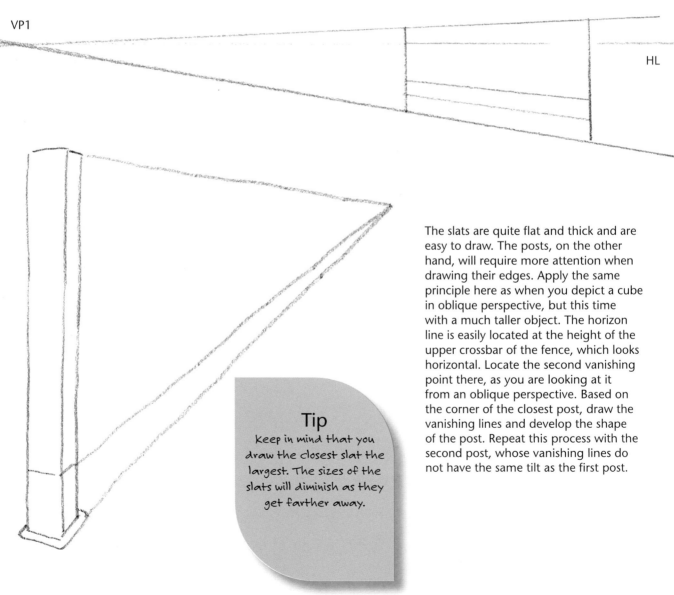

VP1

HL

The slats are quite flat and thick and are easy to draw. The posts, on the other hand, will require more attention when drawing their edges. Apply the same principle here as when you depict a cube in oblique perspective, but this time with a much taller object. The horizon line is easily located at the height of the upper crossbar of the fence, which looks horizontal. Locate the second vanishing point there, as you are looking at it from an oblique perspective. Based on the corner of the closest post, draw the vanishing lines and develop the shape of the post. Repeat this process with the second post, whose vanishing lines do not have the same tilt as the first post.

Tip
Keep in mind that you draw the closest slat the largest. The sizes of the slats will diminish as they get farther away.

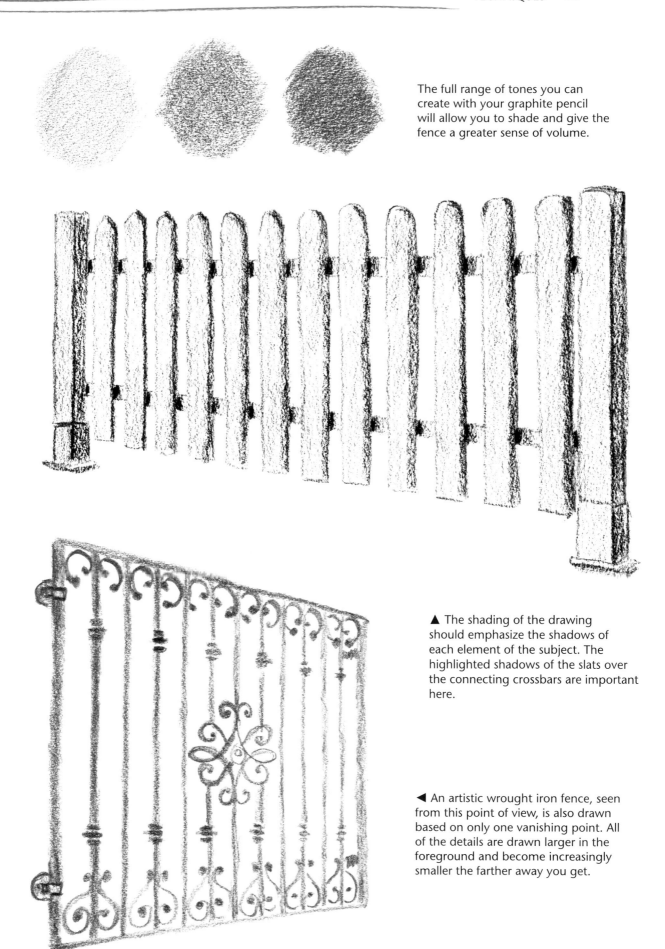

The full range of tones you can create with your graphite pencil will allow you to shade and give the fence a greater sense of volume.

▲ The shading of the drawing should emphasize the shadows of each element of the subject. The highlighted shadows of the slats over the connecting crossbars are important here.

◄ An artistic wrought iron fence, seen from this point of view, is also drawn based on only one vanishing point. All of the details are drawn larger in the foreground and become increasingly smaller the farther away you get.

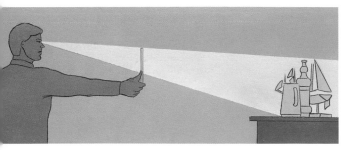

When an object is seen from an oblique view, the vanishing points are not always located on the drawing paper. In these cases, artists must establish the measurements on their own. The slant of the vanishing lines is created without having a direct reference point. The two directions to consider are vertical and horizontal points. Lay them out from the same perspective, in relation to the subject of the drawing, and establish a simple relationship between the distances that makes the most sense for your sketch.

To practice taking measurements, you can use a pencil or a thin brush, keeping the same position in relation to the subject. If you are right-handed, stretch out your right arm and close your left eye. If you are left-handed, do the opposite. You can take measurements vertically (as in the illustration) or horizontally. With your open eye, visualize the distance you are measuring in the subject from two points: one coincides with the tip of the pencil or brush, and the other with your thumb. You only need to measure the necessary distances to establish the relationship between the major elements of your subject. The most important distance is the relationship between the total height and total width.

Taking Measurements

1 First draw a double rectangle on draft paper. This is the part of the subject that is drawn using frontal perspective.

1

2

2 To place the lines of the sketch that will represent the open shutter, you first have to take some measurements. You only need to know: where to place the protruding corner (you can clearly see that it is covering up half of the open window) and at what height it is located (it sticks out at a distance equal to the width of the frame, both on top and on the bottom).

► On colored paper, white pastel pencil represents the brightest tone. You can draw an object in oblique perspective with just this small group of values obtained with pastel pencils and charcoal sticks.

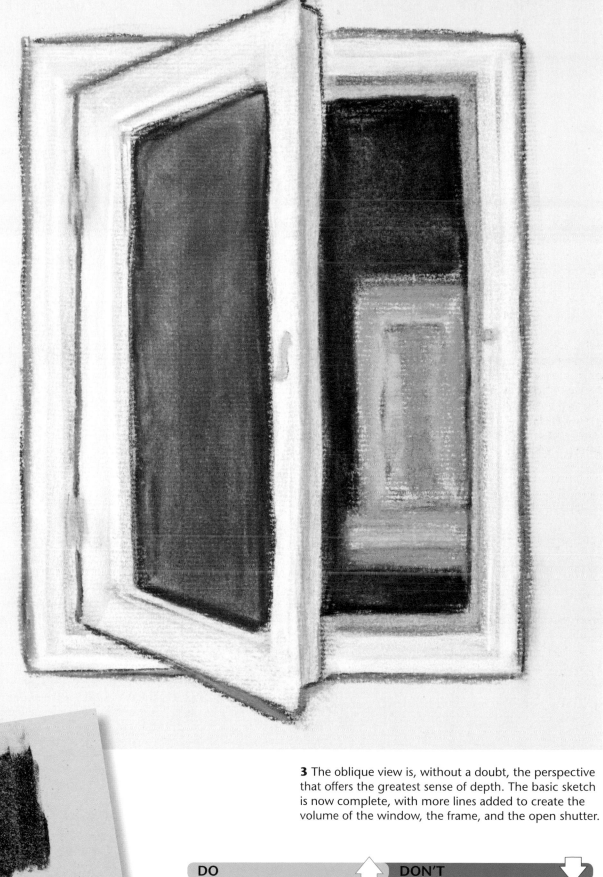

3 The oblique view is, without a doubt, the perspective that offers the greatest sense of depth. The basic sketch is now complete, with more lines added to create the volume of the window, the frame, and the open shutter.

DO	DON'T
Keep your arm straight while you are measuring.	*Change your position in relation to the model when you are taking measurements.*

Everyday Things in Perspective

To practice drawing perspective, the best thing to do is to start by drawing everyday objects. These are basic elements that will appear in our drawings later on, surrounded by various things, and you will be able to sketch them out freehand. Step by step, you will learn to draw them in perspective, first in frontal perspective and then from an oblique view. These examples emphasize the elements that you must focus on in order to easily draw the vanishing lines and locate important points in the drawing.

▲ A pen nib will allow you to make strokes that may better express the model of the subject. Straight strokes are drawn in the direction of the vanishing point; curved strokes describe the cylindrical shapes, and short strokes on different planes that pass through the horizon line divide the subject into sections.

◄ The horizon line of this frontal view is located at a certain point on the back of the chair, with a central vanishing point. The bottom part, marked by the legs of the chair, can be associated with a frontal-viewed cube. You can locate the back legs without difficulty, as these are what give stability to the drawing of the chair. The back of the chair is the same height as the back leg of the chair.

The legs of the chair in a direct frontal-view drawing should be the correct height to make the chair look stable. These are the measurements that you must take and pay close attention to.

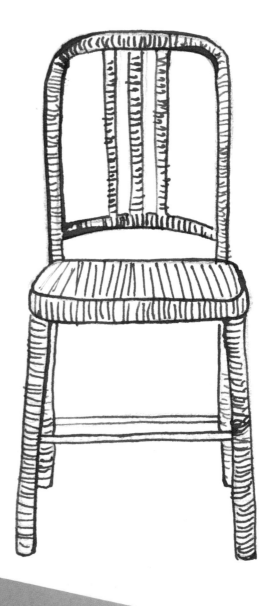

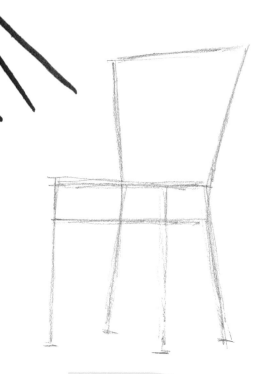

From this perspective, a chair viewed with one leg protruding toward the foreground, the horizon line coincides with the seat of the chair, which keeps you from seeing the surface. However, it is very easy to sketch out the basic outline.

Tip

Practice with different positions and different models. Make sure not to place the outer edges of the four legs on the same line.

Draw the outline with a colored pencil. A tonal range with few values and the white of the paper (for the most brightly lit parts of the subject) will allow you to make the drawing stand out.

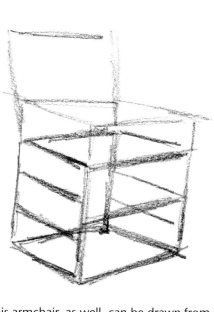

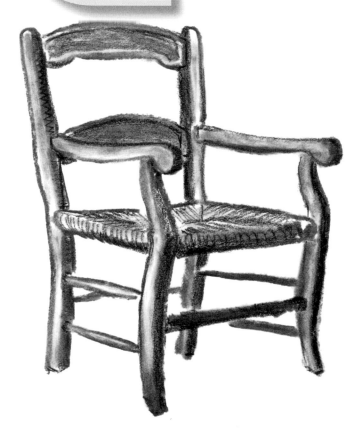

This armchair, as well, can be drawn from an oblique perspective with two vanishing points, following the guideline of the sketch.

A Wall in Perspective

Any wall drawn in perspective creates the sensation of depth. This is easy to do because you can draw without having a precisely located vanishing point. You can "eyeball" the necessary divisions simply and easily. All you have to do is identify the shape of the wall and find the basic details that characterize it. All the vertical lines of the wall will be vertical in the drawing as well, which makes it quite easy to draw.

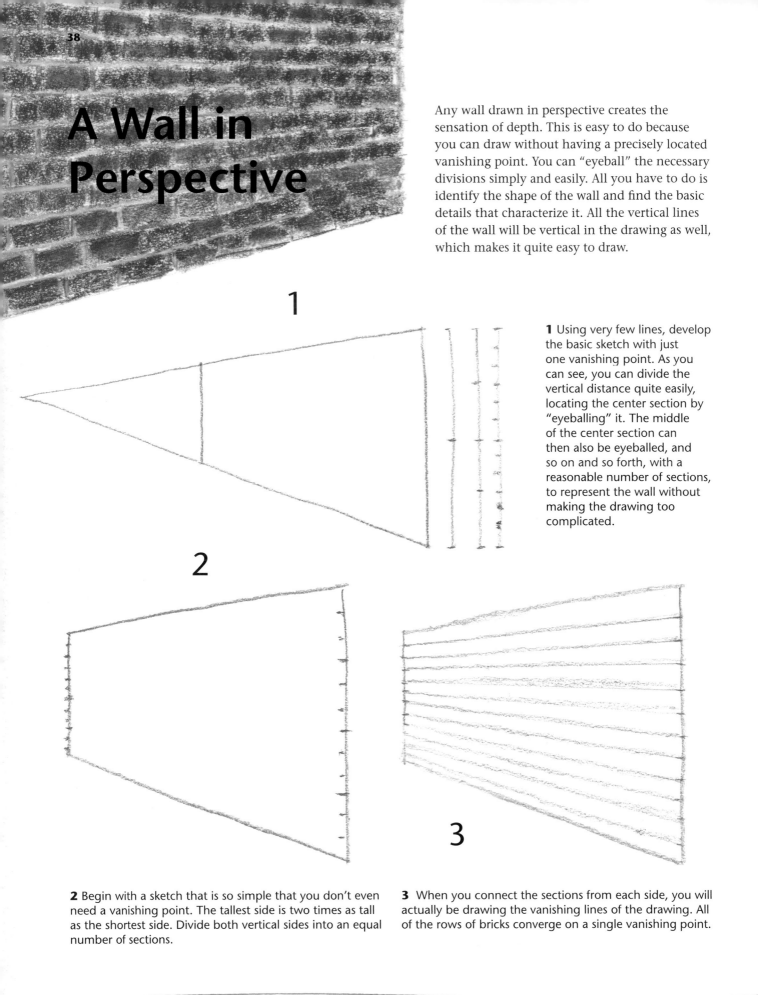

1 Using very few lines, develop the basic sketch with just one vanishing point. As you can see, you can divide the vertical distance quite easily, locating the center section by "eyeballing" it. The middle of the center section can then also be eyeballed, and so on and so forth, with a reasonable number of sections, to represent the wall without making the drawing too complicated.

2 Begin with a sketch that is so simple that you don't even need a vanishing point. The tallest side is two times as tall as the shortest side. Divide both vertical sides into an equal number of sections.

3 When you connect the sections from each side, you will actually be drawing the vanishing lines of the drawing. All of the rows of bricks converge on a single vanishing point.

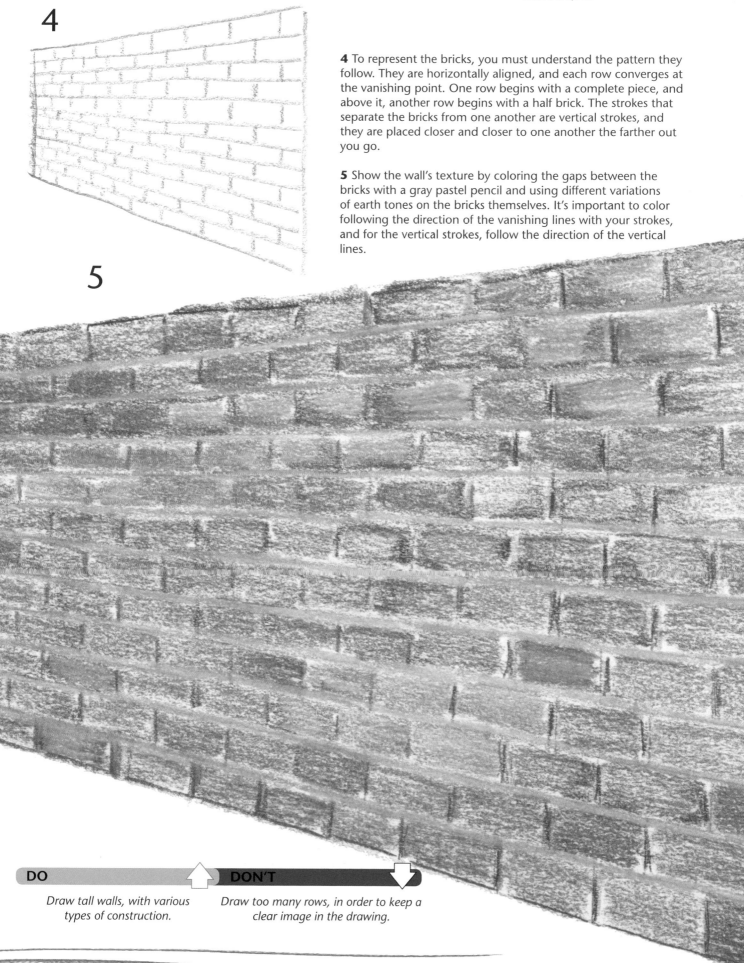

4

4 To represent the bricks, you must understand the pattern they follow. They are horizontally aligned, and each row converges at the vanishing point. One row begins with a complete piece, and above it, another row begins with a half brick. The strokes that separate the bricks from one another are vertical strokes, and they are placed closer and closer to one another the farther out you go.

5 Show the wall's texture by coloring the gaps between the bricks with a gray pastel pencil and using different variations of earth tones on the bricks themselves. It's important to color following the direction of the vanishing lines with your strokes, and for the vertical strokes, follow the direction of the vertical lines.

5

DO ⬆ **DON'T** ⬇

Draw tall walls, with various types of construction.

Draw too many rows, in order to keep a clear image in the drawing.

Stone Walkway in Perspective

Drawing a stone walkway in perspective is a common way to create a greater sense of depth. In this case, like in the example on the previous page, you don't even have to indicate the vanishing point. You can simply eyeball the divisions you need. Locate the middle of the walkway, and then the midpoint of that section, and so on. This example is a more artistic-looking walkway, made up of cobblestones to give it a classic look. With minimal details, you can give your drawing a sense of depth. Remember that only the horizontal lines of the gaps in the walkway are kept horizontal. The other lines are vanishing lines.

1 The vanishing point will help you create a simple sketch of the drawing. Plan out how to divide the lower base of the walkway, which is twice the length of the upper base.

2 Without a vanishing point, define the relationship between the upper and lower bases by dividing the length of the upper base. It's all very simple.

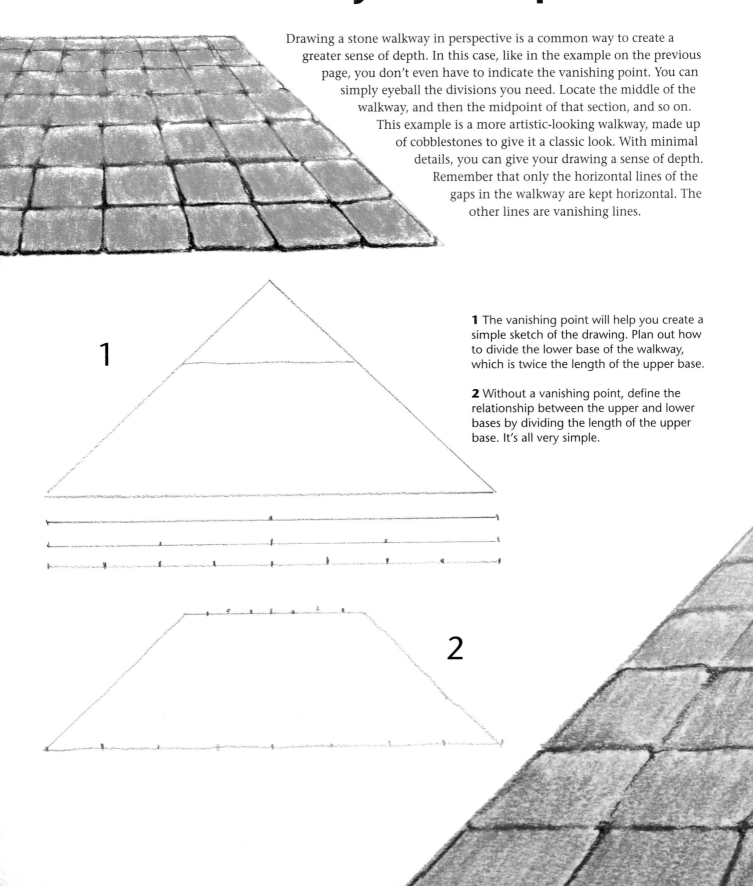

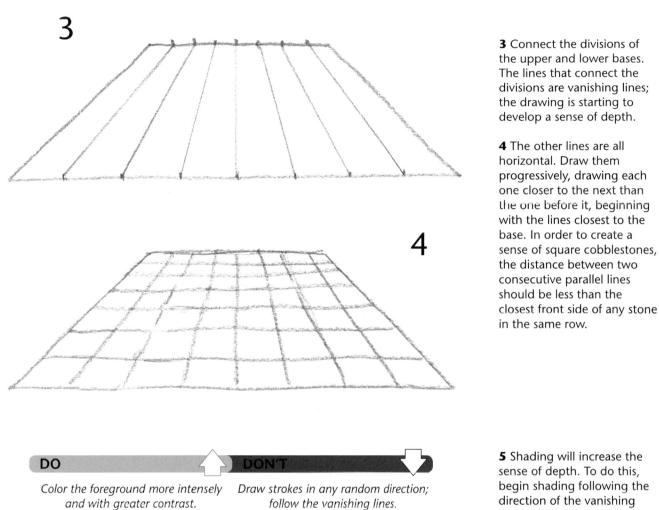

3 Connect the divisions of the upper and lower bases. The lines that connect the divisions are vanishing lines; the drawing is starting to develop a sense of depth.

4 The other lines are all horizontal. Draw them progressively, drawing each one closer to the next than the one before it, beginning with the lines closest to the base. In order to create a sense of square cobblestones, the distance between two consecutive parallel lines should be less than the closest front side of any stone in the same row.

DO	DON'T
Color the foreground more intensely and with greater contrast.	*Draw strokes in any random direction; follow the vanishing lines.*

5 Shading will increase the sense of depth. To do this, begin shading following the direction of the vanishing lines. Gray pastel pencils can provide all the different tones of the stone walkway, and will allow you to develop their cobblestone characteristics.

Urban Scene

A common element of any urban cityscape is the point where a wall meets a road or walkway. Following the previous examples, it is very easy to create this setting. Use a shared vanishing point. Measure the space that is occupied by the walkway and the wall, and with just a few more details, you can develop their characteristics. Shade or color both spaces as needed, and you will create a powerful sense of depth.

1

2

1 Referencing a vanishing point allows you to measure the entire space of the initial sketch with just three lines.

2 Draw two parallel horizontal lines to divide the space occupied by the walkway.

3

3 Based on the two horizontal lines, draw vertical lines. These lines divide the space occupied by the wall.

4 For the general sketch, establish simple relationships. The lower base of the walkway is twice the length of the upper base. For the wall, the near edge is one-and-a-half times the length of the far edge. Simply divide each space into equal parts and connect with straight lines. All of these lines are vanishing lines that converge at a vanishing point, although it does not appear in this sketch.

4

DO	DON'T
Practice outdoor sketches. Try to always carry a small notebook and pencil with you to do this.	*Draw the same details on the wall and the walkway in the same drawing.*

5

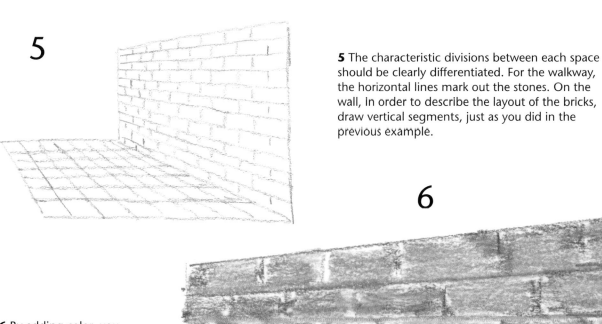

5 The characteristic divisions between each space should be clearly differentiated. For the walkway, the horizontal lines mark out the stones. On the wall, in order to describe the layout of the bricks, draw vertical segments, just as you did in the previous example.

6

6 By adding color, you will give both elements a greater sense of depth. For even more emphasis, color both areas with pastel pencils, following the direction of the vanishing lines.

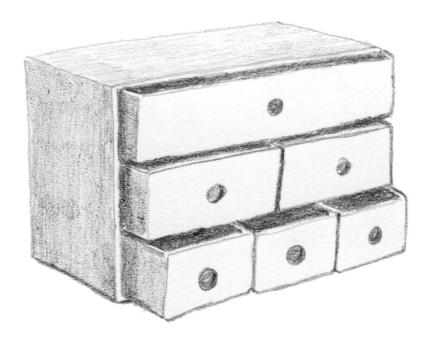

Once you know how to draw a subject with flat surfaces from the most common perspectives, it is easy to develop a sketch of various elements that make up a subject or group of subjects. These elements all fit together in one sketch; you simply have to sketch some vanishing lines to locate them. Although there may be variations, it's enough to just adapt the basic sketch into your final drawing. These examples are based on an oblique view of two very common examples.

To draw an open drawer, first develop the closed drawers to use as an example, based on two vanishing points. Following the basis of this sketch, draw the open drawer as well, with lines leading to the same vanishing points.

Adapting Your Basic Sketch

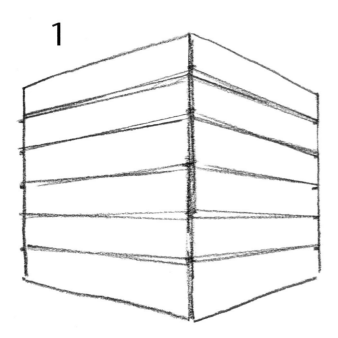

1 Draw this common subject, viewed from an oblique perspective, based on a basic sketch that is divided up into sections, following the direction of the vanishing lines and divisions.

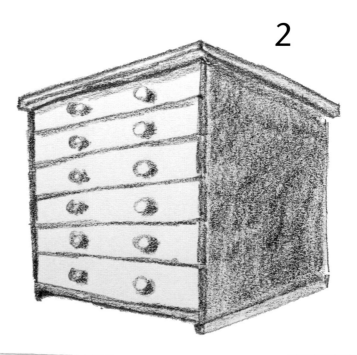

2 Draw the nearest knobs larger and the farther ones smaller.

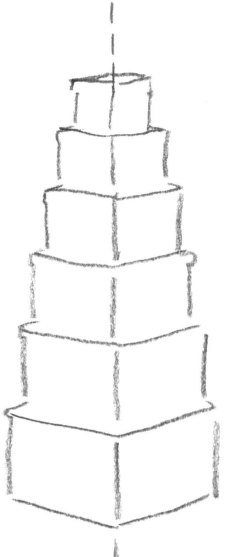

◄ The main lines of this combination of objects clearly show a symmetrical axis. In this example, all the lines needed to draw these objects converge at the same two vanishing points. Although we cannot place the points exactly, we know that they are located along the horizon line, which is located just above the tower of boxes.

► This sketch allows us to better see how, at different heights, each object gives us a different view of its top. The higher the box, the less visible its top is. Given the fact that the highest box top is hidden, you only have to trace the vanishing lines that are increasingly horizontal. In order to represent each box top, the lines should follow the same vanishing lines as the box bottom, but the box top should be wider than the box so that the box appears to fit inside it.

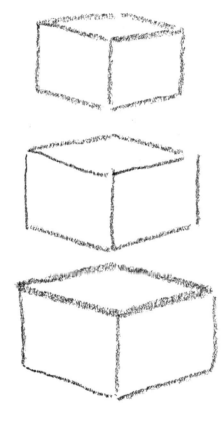

Tip

In the beginning, draw combinations of objects from the same oblique view. Don't draw parallel vanishing lines, since these lines, by definition, should converge at a vanishing point.

By making one side more brightly lit than the other, you will create a greater sense of volume.

Domes

A dome is a very common shape in architecture. There are short domes, tall domes, circular or flat-sided domes, and the general technique for drawing them is quite easy. They are often seen from a fully frontal view or from slightly above or below. All you need to remember is how to sketch the representation of a half-sphere, as seen from these viewpoints, and then adapt the general sketch for each type of dome.

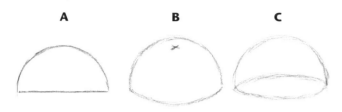

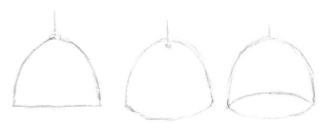

The basic sketch, seen from the front (A), slightly above (B), and slightly below (C).

Adapt the basic sketch to represent a taller, more elongated dome, with the three viewpoints that are visible here.

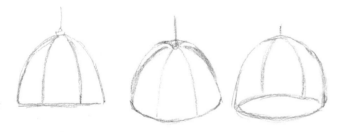

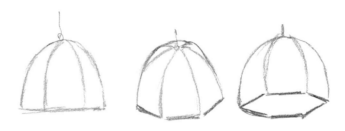

Some domes have vertical lines on them. These lines are represented as circumference arches that begin at the highest point on the dome.

On some domes, the vertical lines are arches following the curvature of the sphere, but between each line there is a flat surface. This should be shown in the sketch, whether representing a view from above or a view from below.

Some domes have polygon-shaped bases, drawn with straight lines. These domes can be adapted from the same basic sketch.

With a pronounced view from below, all the details seen from an aerial perspective vanish.

Tip

Pay attention to the base of the dome. Is it straight, concave, or convex? Only draw the most characteristic features, without using too many details.

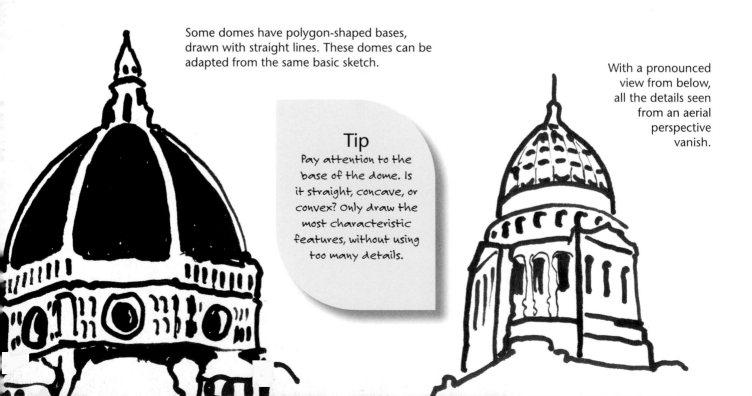

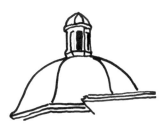

There is an infinite variety of dome types. This dome, for instance, flares out at the base. See how it is represented in the drawing.

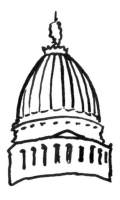

Viewed from below, the base is represented by parts of flattened circles.

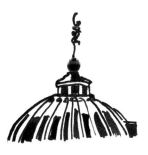

A dome is an element that appears in the background of many urban scenes.

▶ An urban cityscape with a viewpoint from above the city is very attractive, and easy to represent, if you stick to larger, regular shapes and draw various domes, paying attention to their particular details.

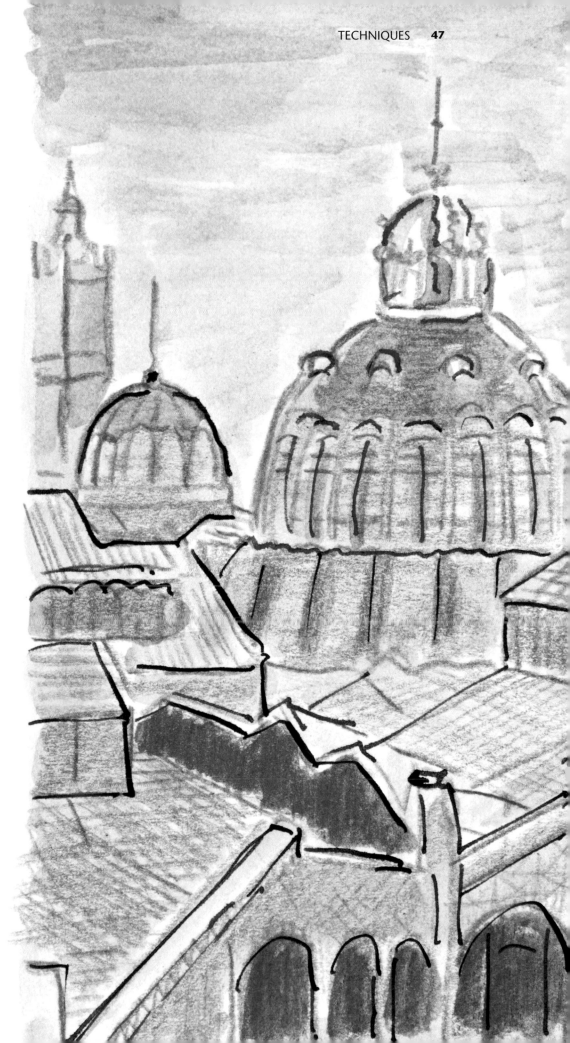

The frontal view is the easiest perspective to draw. In addition, it allows you to covey depth very well. All you need to do is add a detail here and do some shading there. First off, study the subject to see how symmetrical it is, and then add elements with vanishing lines. Evaluate the path of light and establish a small, but sufficient, tonal range. Give the most intense tone to the areas in shadow. Classify the cast shadows according to their intensity, and shade them in order, from lightest to darkest. Step by step, you will create a drawing that produces a magnificent sense of volume.

▲ Graphite pencils allow you to produce a total range of four values. Apply these values to the sketch in order, from lightest to darkest, to complete the drawing. For the brightest highlights, leave the white parts of the paper blank, without drawing or shading them.

Enriching the Frontal View

1

1 On a separate sheet of paper, draw a sketch of the subject from a frontal view. This is the shape of a typical doghouse.

2 It's good for there to be some details that add more depth to the subject—in this case, the vanishing lines on the roof. Represent the roof with only a slight view of the eaves.

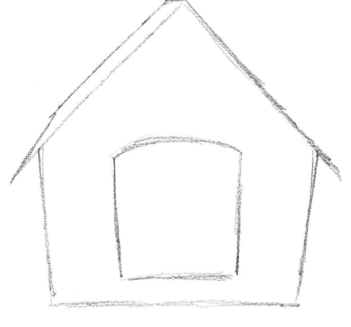

2

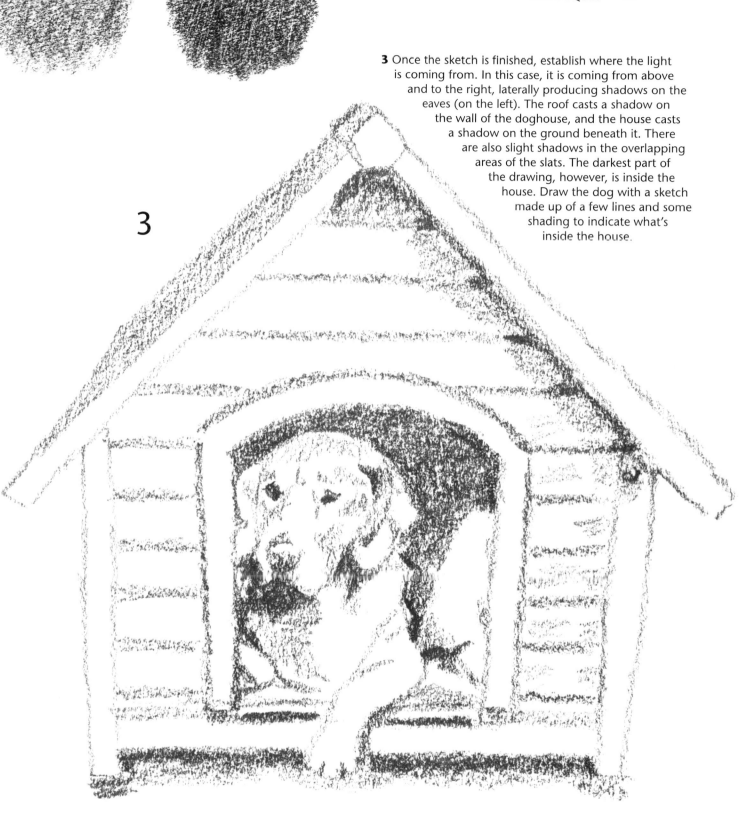

3 Once the sketch is finished, establish where the light is coming from. In this case, it is coming from above and to the right, laterally producing shadows on the eaves (on the left). The roof casts a shadow on the wall of the doghouse, and the house casts a shadow on the ground beneath it. There are also slight shadows in the overlapping areas of the slats. The darkest part of the drawing, however, is inside the house. Draw the dog with a sketch made up of a few lines and some shading to indicate what's inside the house.

3

DO	DON'T
Stick to a small tonal range in the beginning, without too many values.	*Shade the entire drawing with the same intensity.*

The frontal point of view is very easy to draw.

All objects that have a flat surface can be reduced to a simple sketch. It's a good idea to break the subject down into its parts. Start with the basic sketch of the basic parts of the subject, applying what you already know about the perspective of a cube. The shape may be more elongated, narrower, or taller, but the principle is the same, whatever the view of the subject may be. Afterward, finish the sketch with a few more strokes.

Analyzing Shapes

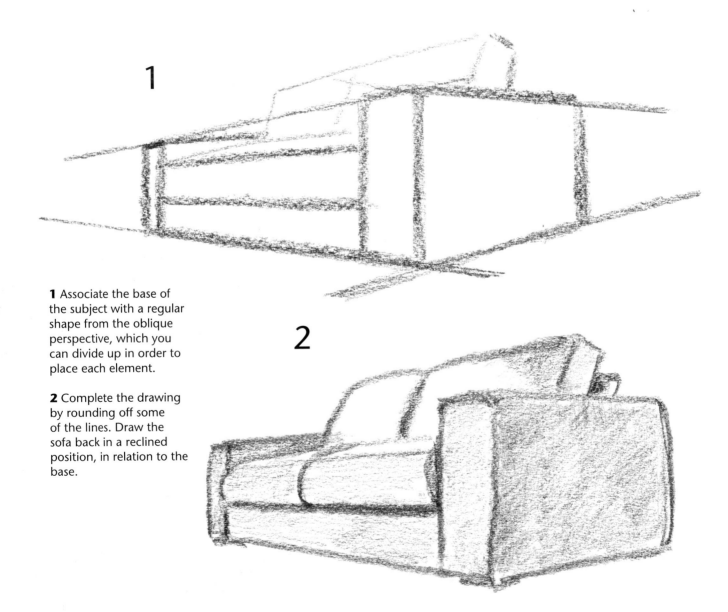

1 Associate the base of the subject with a regular shape from the oblique perspective, which you can divide up in order to place each element.

2 Complete the drawing by rounding off some of the lines. Draw the sofa back in a reclined position, in relation to the base.

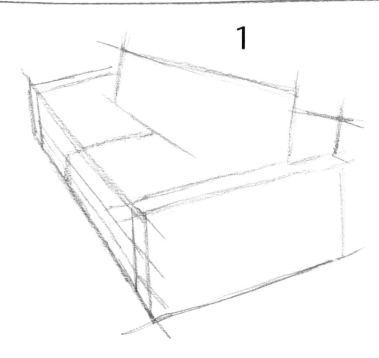

1

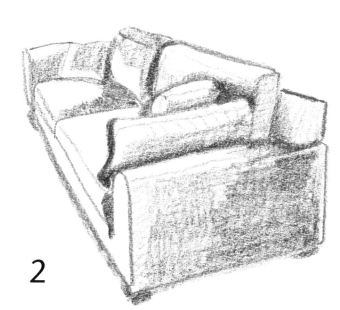

2

1 This other viewpoint allows you to easily draw the vanishing lines. The outline of the back of the sofa also vanishes towards the same vanishing point as the more convergent lines of the base and cushions. The other series of lines of the parts more visible on the top converge at a second vanishing point.

2 The cushions and cushioned parts of the sofa have rounded shapes that also follow the general vanishing lines.

> ## Tip
> Reduce the characteristics of the subject to their most basic, essential shapes.

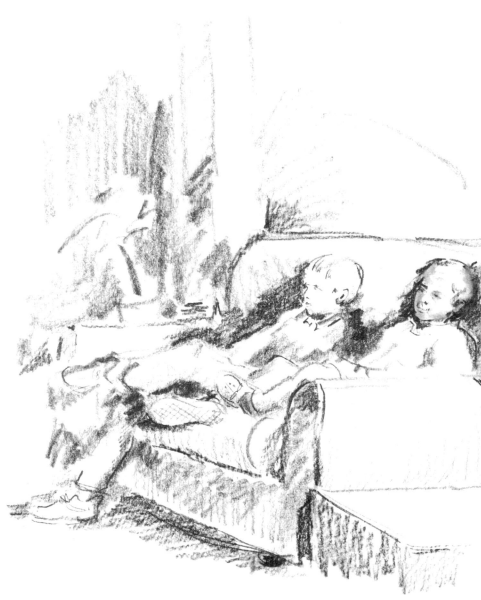

When you know how to draw a sofa, love seat, or easy chair, you will be able to draw more complex scenes, including seated or reclining figures. In this case, the sofa and its sketch are framing the figures, allowing you to give them the correct proportions and posture.

The Different Planes

When necessary, it's important to be able to distinguish between different planes. For example, the closest object must appear to be in the foreground, and the farthest object should appear to be in the background. Various planes can be established, from near to far. This example includes two very different planes: the foreground, which includes the subject and the background, which establishes the setting. The basic sketch will be made up of lines defining the background and the sketch of the subject, properly placed inside these lines. Simple relationships between objects help to represent distance and make it easier to create your drawing.

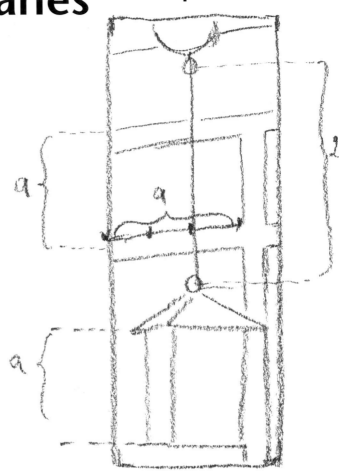

1

1 By establishing the relationship between certain distances, you will be able to place the elements in the drawing easily.

2

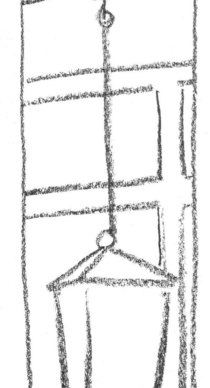

2 The sketch of the background is limited to very few lines. The vertical lines are kept vertical. The rest of the lines are not horizontal but rather drawn a bit slanted. The subject in the foreground is centered in the width of the drawing, from the hanging connection downward to its base. In order to place the subject among its surroundings, look for something that relates the distances in the scene vertically or horizontally. In this case, a good reference is the length of the windowpane marked "a."

3

3 Represent the object with a very simple sketch from the oblique view. The same principle as the cube is used here, only in this case, the figure is taller and has a pyramid shape on top. The height is a third larger than the width. By marking the divisions of the lamp, you can then measure out the glass panes. For the sides, the same rule applies: the closer the part of the object, the larger you draw it, and the farther the part, the smaller you draw it.

▲ Charcoal sticks allow you to create interesting contrasts between light and dark, with intense, vigorous strokes and outlines.

4

4 The subject and the chain it hangs from, which make up the foreground of the drawing, are shaded with charcoal sticks, creating a greater contrast between light and dark. To represent the distance of the background, shade it lightly and make the strokes less intense. It is very easy to achieve a range of tones with charcoal, due to its capacity for smudging and fading.

DO

Practice the tonal range of charcoal sticks on a separate sheet of paper, before shading the final drawing.

DON'T

Shade the foreground and background with the same values and contrast.

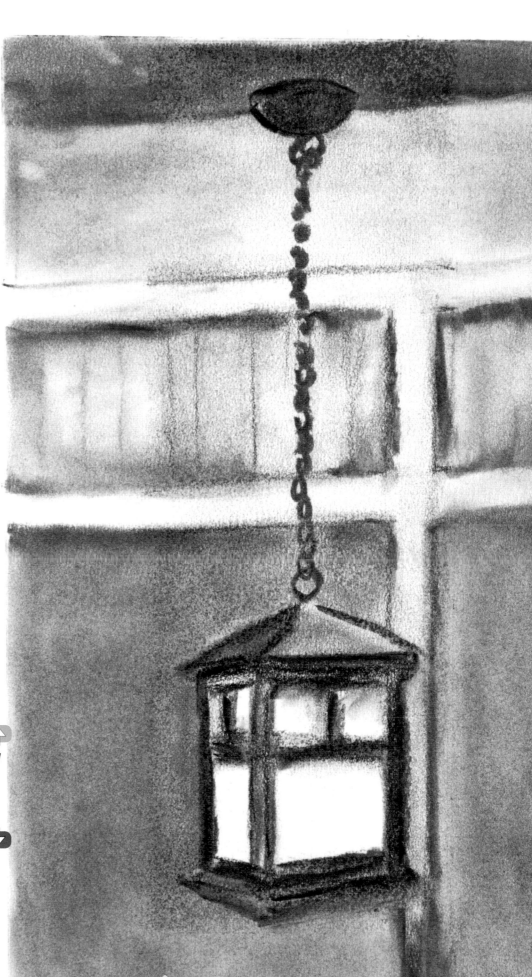

If you decide to work with more daring examples, you will achieve beautiful results. With this in mind, using the oblique perspective with a large foreground will increase the observer's sense of proximity to the subject. There is no need to move away from the horizon line. Any element without flat sides can be drawn with a few descriptive lines to develop foreshortening. Once the sketch is done, coloring and shading with hatching will emphasize the direction of the vanishing lines and create volume and depth in the drawing.

Oblique Perspective

VP1

VP2

HL

1

2

1 It's quite easy to draw this bag. On the a separate sheet of paper, sketch the bag as small as possible so that you can see the vanishing points.

2 Figures without flat surfaces seen in perspective (such as this kitten) can be represented with just a few lines. There aren't many of them, and they are easy to sketch.

3

3 Draw the basic sketch with definitive lines on your final drawing. With the sample sketch for guidance and knowing where each line is headed, you will be able to draw the basic outline for the final colored drawing.

A Pastel pencils will allow you to create hatching very easily.

B Tones are created by adding one hatch on top of another. However, you can express better volume if your strokes follow the direction of the vanishing lines. For this reason, it's a good idea to have an idea of where these vanishing points are located.

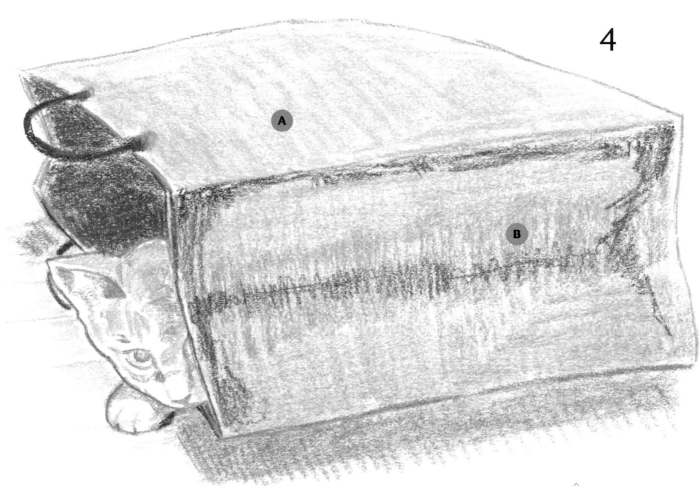

4

4 Of all the color values and tones present within a subject, the most important are the brightest highlights and the darkest shadows. The darkest area—in this case, the inside of the bag—blocks the central element of the subject (the cat's head) and emphasizes it. The lightest part corresponds to parts of the feline's head, and creates even more contrast against the nearby dark area.

DO

Transfer the sketch to your final paper with the same medium you plan to draw with.

DON'T

Make a sketch with too many details.

Interior Perspective

To draw an interior, it is common to use only one vanishing point. You must first locate and draw four vanishing lines: these are the lines that limit the lateral walls; the lines along the floor, and those bordering the ceiling. These four lines converge at a single vanishing point. Once you have placed the vanishing point, you will be able to draw the remaining vanishing lines that will help you draw all of the other elements of the interior.

A Place the vanishing lines that appear darkest first. These lines represent the edge of the lateral walls along the floor. They are easy to locate, and they will indicate where to place the horizon line, which should be at the height of your gaze. And, given the fact that they converge, you can also easily locate the vanishing point.

B Proceed in the same way for the two lines along the ceiling. These lines, of course, will converge on the same vanishing point as the floor.

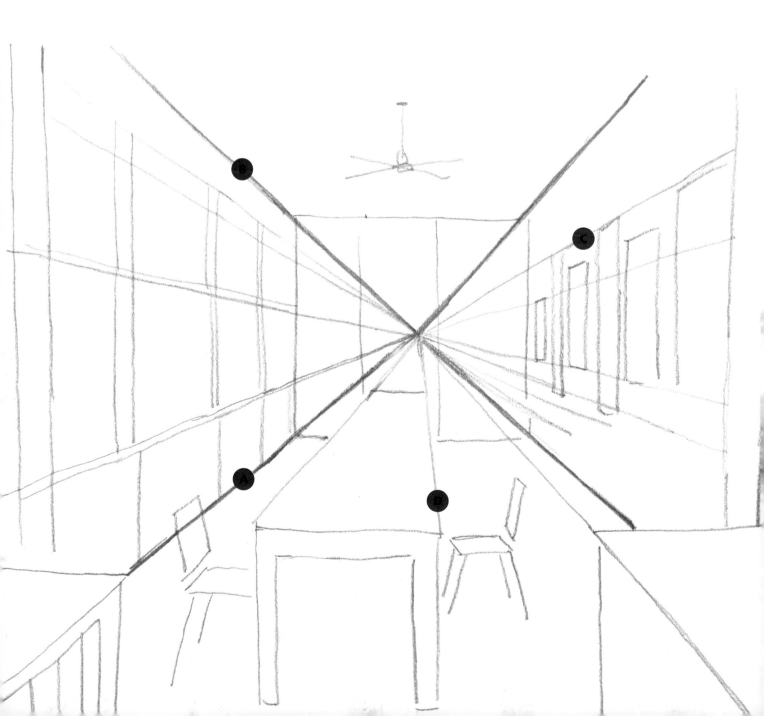

C In order to draw the elements that appear on the lateral walls—in other words, the separations of the windows and frames—draw more vanishing lines that converge on the same central vanishing point.

D As long as you use the same vanishing point to draw the tables, they will be easy to draw as well.

E Using this type of perspective, all the vertical lines in the room are also vertical lines in the drawing. Draw the parallel lines that divide the windows, the lateral lines for the frames, and the legs of the tables.

F The details of the curtains enclose the background of the room with two horizontal lines and two vertical lines, forming a simple square.

G To complete the drawing, add some descriptive details to all the objects. Apply different shades with graphite pencil to represent depth in the drawing.

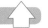
DO

Keep in mind that all of the elements in this sample drawing are distributed evenly throughout the room, which allows you to use the same perspective for all of them.

DON'T

Make the ceiling or the floor look crooked.

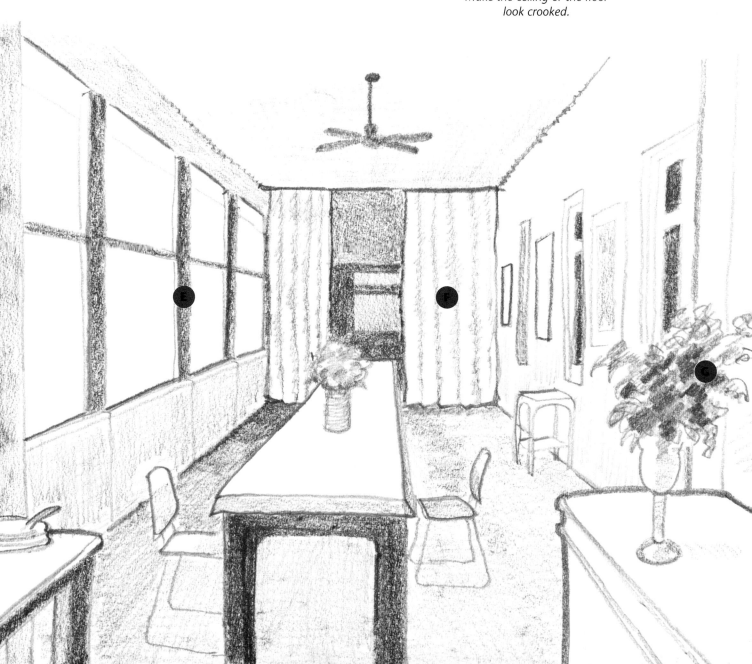

Vanishing Lines

The sketch for this example is similar to the drawing of the wall that you did in a previous exercise. This simple drawing also has just one vanishing point. The general lines dividing the blocks are vertical, and the lines dividing the floors follow the horizontal vanishing lines. The space for each floor is divided into three parts, and the vertical lines that separate each of the blocks get closer together the farther away you go. With just a few details, you will have a beginning sketch to work with, and then all you'll need to do is color it in.

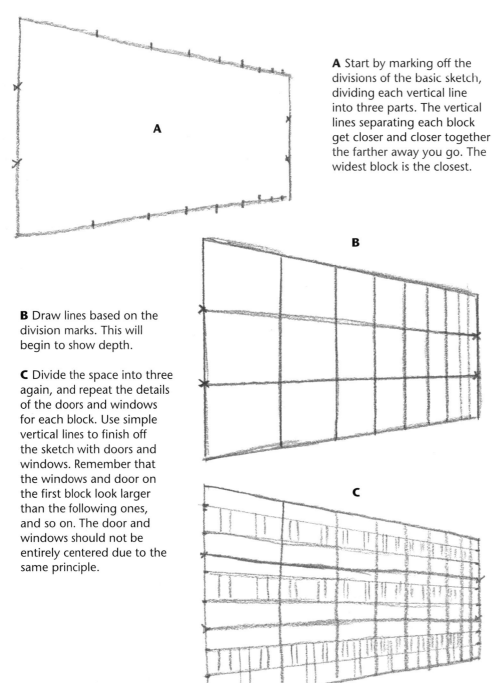

A

B

C

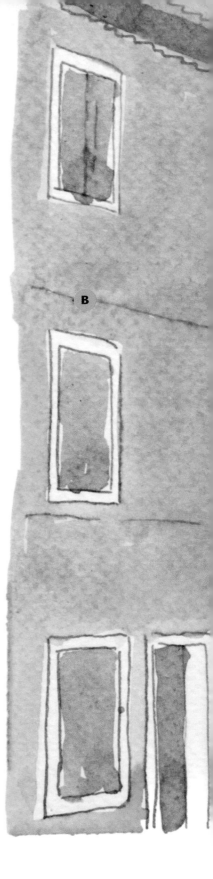

B

A Start by marking off the divisions of the basic sketch, dividing each vertical line into three parts. The vertical lines separating each block get closer and closer together the farther away you go. The widest block is the closest.

B Draw lines based on the division marks. This will begin to show depth.

C Divide the space into three again, and repeat the details of the doors and windows for each block. Use simple vertical lines to finish off the sketch with doors and windows. Remember that the windows and door on the first block look larger than the following ones, and so on. The door and windows should not be entirely centered due to the same principle.

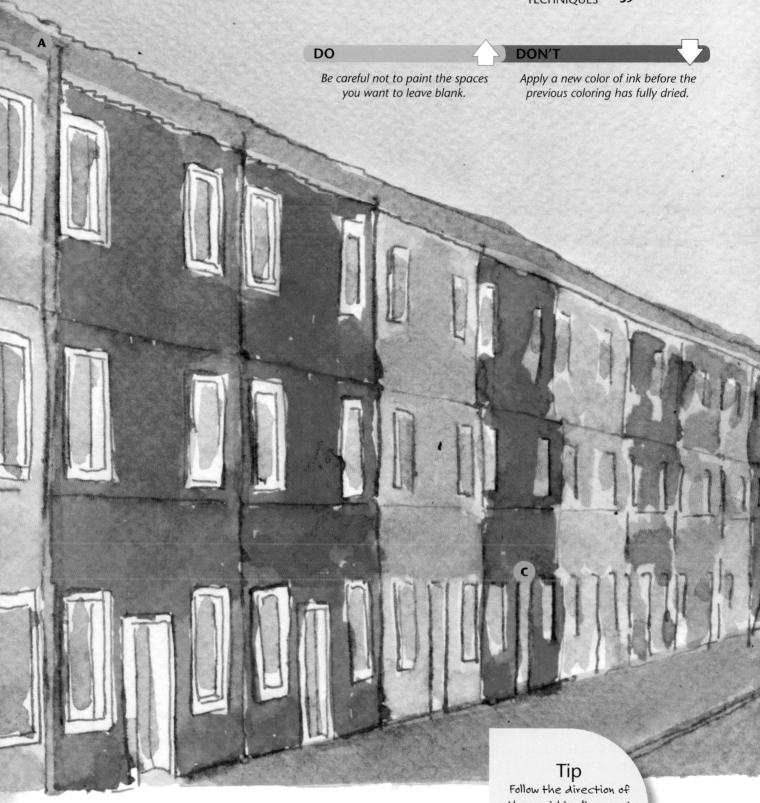

A

Be careful not to paint the spaces you want to leave blank.

Apply a new color of ink before the previous coloring has fully dried.

C

Tip

Follow the direction of the vanishing lines and vertical lines when going over them with the pen nib. Remember that ink is not easy to correct!

One great option for this type of drawing is to use a pen nib, brush, and ink. Draw the sketch lightly with a graphite pencil. Then carefully draw over the pencil marks with the nib and ink. Once the ink is dry, erase the pencil marks carefully. Then fill in the marked spaces with different colors of ink.

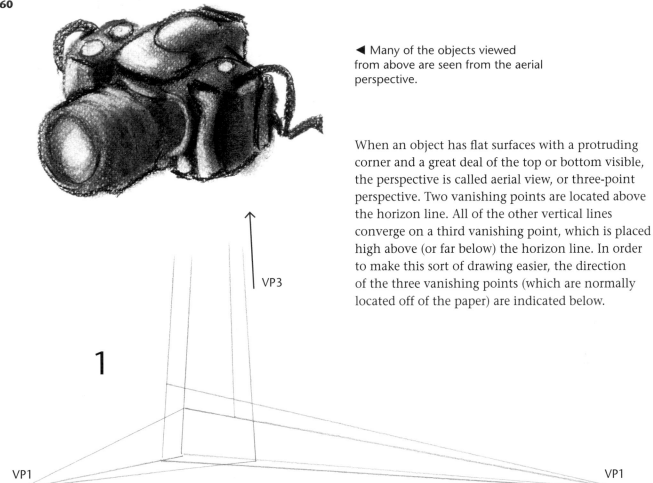

◄ Many of the objects viewed from above are seen from the aerial perspective.

When an object has flat surfaces with a protruding corner and a great deal of the top or bottom visible, the perspective is called aerial view, or three-point perspective. Two vanishing points are located above the horizon line. All of the other vertical lines converge on a third vanishing point, which is placed high above (or far below) the horizon line. In order to make this sort of drawing easier, the direction of the three vanishing points (which are normally located off of the paper) are indicated below.

1

VP3

VP1 VP1

HL

Aerial Perspective

1 A balcony with a protruding corner is reminiscent of a cube viewed from the oblique perspective. In this case, the lower part is visible. The horizon line runs below the balcony and remains on the horizontal plane, which is at eye level with the viewer. Two vanishing points can be easily placed on the horizon line. There are many parallel lines on the balcony that, when represented in the drawing, converge on these two vanishing points. The third vanishing point is located far above the horizon line. It's interesting to notice that the vertical lines on the balcony converge on the third vanishing point. You should allow them to lean in this direction a bit when drawing them.

2 Draw a simple sketch to begin, using light strokes so that you can erase some of them later.

2

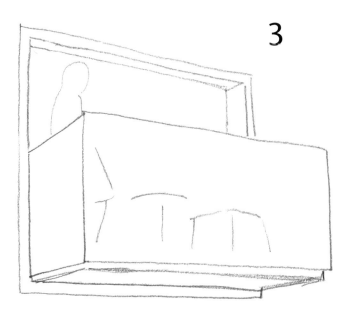

3 Following the example, draw some more lines to represent the protruding part of the balcony. Make a few notes to place the figure and the furniture.

4 A finished drawing of an aerial view, when properly shaded, creates a great sense of depth.

DO ⬆

Pay attention to the details on the front of the balcony, which look horizontal to you, when placing the horizon line.

DON'T ⬇

Forget to draw the vertical lines as if they converge on a third vanishing point.

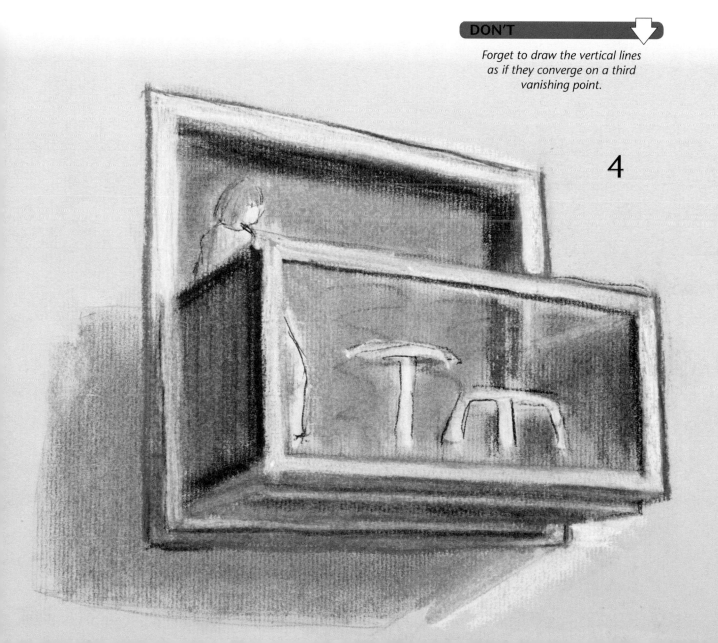

Open Landscape

The vista of an open landscape without any buildings is quite easy to draw. A simple sketch, based on just a few lines, divides the space. In order to draw these lines, you must take a few things into consideration: the horizon line is a straight line; the parallel lines on the subject are convergent, as is the case with the road; the line of the poles follows the road, and its height becomes shorter and shorter with distance; and finally, everything should be drawn larger in the foreground and become gradually smaller as it moves into the background.

A

A In order to draw an open landscape, you must first divide the space on the paper. The horizon line is very easy to locate, since in a seaside landscape like this one, it is the line that separates the sky from the ocean. The most important point you will place is the X Point, based on simple measurements: three-fourths of the width and two-thirds the height of the drawing. A series of curved lines follow the outline of the road and converge on this point. The dotted line along the tops of the poles runs above this point.

B Draw the sketch onto your final paper with a light gray pastel pencil. Complete the drawing with more lines to separate the light from the shadows and others to better portray the elements in the foreground. The poles, although they are simply drawn as vertical lines, are an important element for showing depth.

B

C After initially coloring with pastel pencils, apply a layer of charcoal to obtain night tones. Smudge it with your finger in some areas of the drawing to develop fading.

C

In this nighttime scene, shade with greater contrast in the foreground. The largest details, drawn with the most emphasis, should decrease in contrast the farther away you go. The stretches of the road are horizontal lines, and the distance between them decreases as necessary.

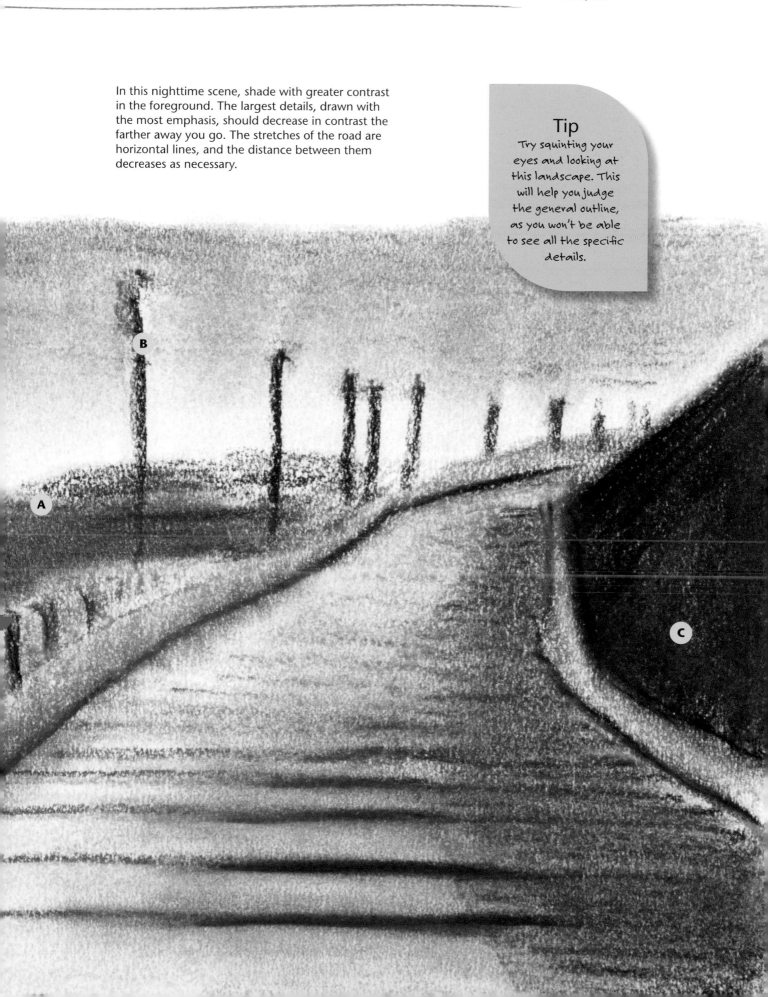

The one-point perspective is used to draw all the elements of an urban scene: buildings, sidewalk, doors, windows, balconies, traffic lights, trash cans—and human figures. It's important to draw the figures that appear in the foreground in relation to the height and width of the elements in their urban setting: a door, a window, the sidewalk, a trash can, or a traffic light.

Human Figures in Perspective

▲ In an urban scene, all the human figures and objects are drawn based on the same vanishing lines as their surroundings.

◄ First draw the surroundings—the buildings and sidewalk. Several lines converging on the same vanishing point are used to place the doors, sidewalk, and street. The closest figure is located in the middle of the sidewalk, framed by the door in the background for reference. Draw the vanishing lines at the height of his head and feet heading towards the same vanishing point. Repeat the same basic sketch for this figure, making the others progressively smaller and keeping them between these two lines.

▶ To draw human figures, it's a good idea to practice with a mannequin in different positions. Some people are taller than others, but the vanishing lines keep the general tendency of figures to become shorter the farther away they are.

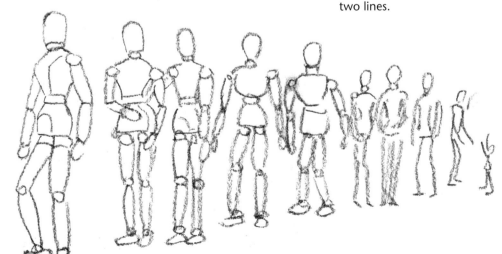

Drawing several people standing in line is a simple, practical way to use the vanishing point. Just a few strokes will show their clothing, complementing the spherical and cylindrical shapes that make them up.

Draw the figures in the foreground the largest, making them increasingly smaller as you work your way through the middle ground and into the background.

Tip
Start with standing figures, making quick sketches and drafts. Then take a shot at drawing seated figures.

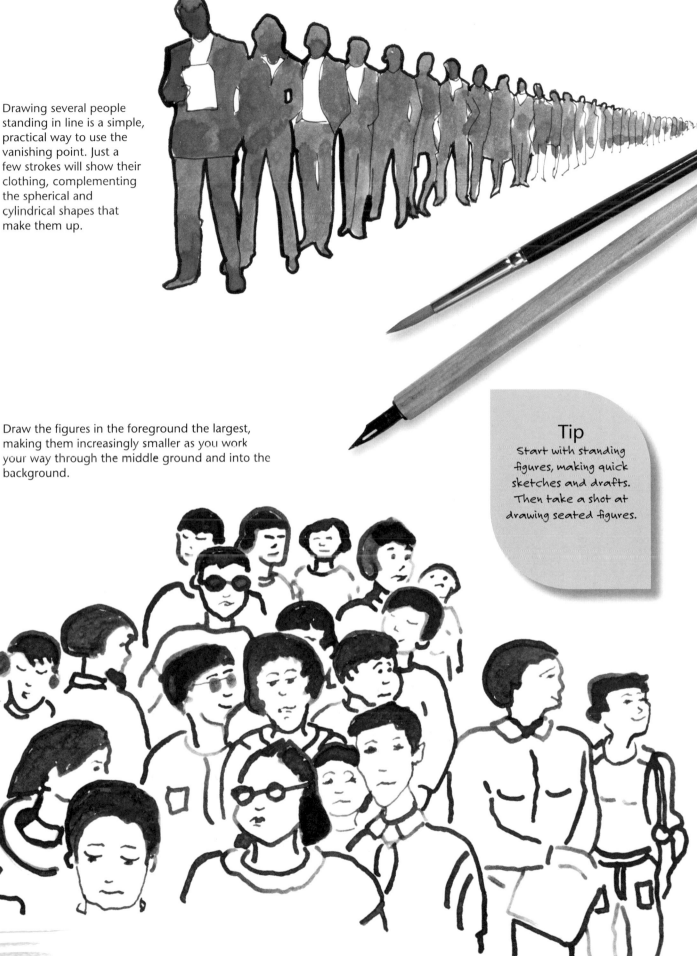

Arches in Perspective

It's very easy to draw the basic sketch of an arch, associating its shape with others that you already know how to draw. As for the pillars of an arch, remember that the pillar closest to you should be higher and thicker than the farther one. From an oblique view, the line that shows the depth of the arch is very important, as this is the line that represents its volume. It's quite easy to draw, and an arch drawn in perspective will allow you to draw plenty of other things, such as a bridge stretching over a river.

1

2

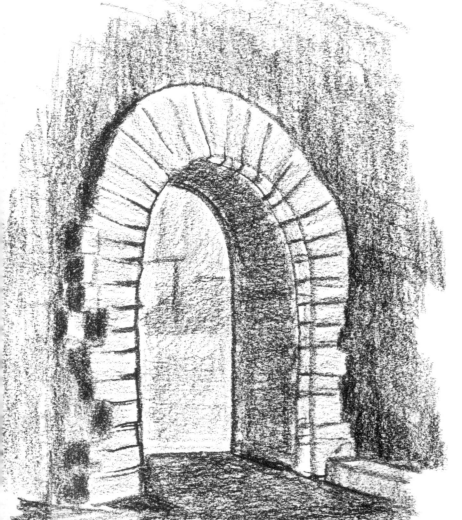

1 It's very easy to draw the general sketch. This is an oblique view, with the horizon line located at the base.

2 To include the arch in the basic sketch, draw a few curved lines. The closest pillar is drawn wider and taller than the farther one. For this reason, you won't be drawing the arch in the center. The line that depicts the depth of the arch is also the edge of the farther pillar, which should be depicted with less depth than the closer pillar. Since this is an oblique view, not all of the inside of the arch is visible—just a part of it.

◄ In order to draw a gate or opening in a wall from an oblique point of view, apply the same technique.

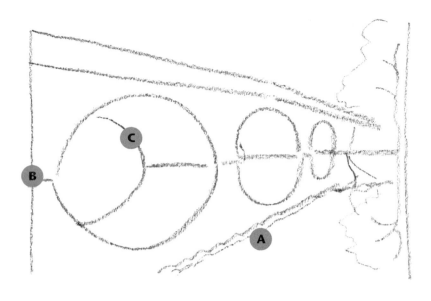

In order to draw the sketch of a bridge with arches, you must adapt the sketch and consider these points:

A The symmetry of the bridge and its reflection on the water of the river.

B The three important vanishing lines: the line indicating the top of the bridge, the line indicating the points of contact with the water, and the line showing where the bridge's reflection on the water ends.

C The line that indicates the depth of the arch only shows on the closest arch. You don't have to do this for the others, as the depth of the pillar fills the entire view.

Tip
Clearly distinguish the actual bridge from its reflection in the water. Use two different textures, but keep following the same vanishing point.

▼ Sanguine is one of the most suitable media for drawing a scene with a bridge and arches.

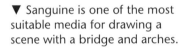

Subjects

In the first section of this book, we learned how to represent some basic situations of perspective. In the second section, we will go over the techniques in more depth and apply them to more common subjects that involve elements of perspective. This will teach you how to create a greater sense of depth. All of the subjects in this section can be drawn with very easy, basic sketches. If you use the suggested technique for each subject, you will end up with some very easy-to-draw, lovely works of art.

Hammock in Perspective

There are a lot of objects that you can draw based on very similar sketches. This hammock, viewed in perspective, is laid out as a section of a sphere. This is similar to the example of drawing a slice of watermelon. To draw the basic sketch, it's a good idea to go back to thinking about it as a section of a sphere and sketch it as such to properly develop the viewpoint of the hammock. Once you have it sketched out, you can add color, remembering the principle: the closer something is to you, the larger you draw it.

1

1 Draw the sketch of the watermelon slice with just a few strokes.

2 To sketch the rind, erase the straight line on top and draw in another curved line.

2

3 To adjust this sketch, switch it to a point of view from below the hammock. Adjust the two connecting points, one of which is now higher up than the other.

▼ Pastel pencils are great for drawing lines. For this reason, they are ideal for drawing this sort of subject.

3

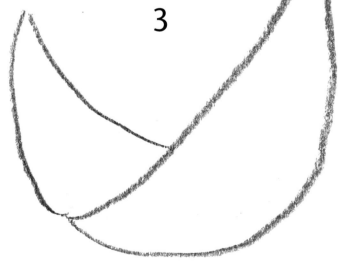

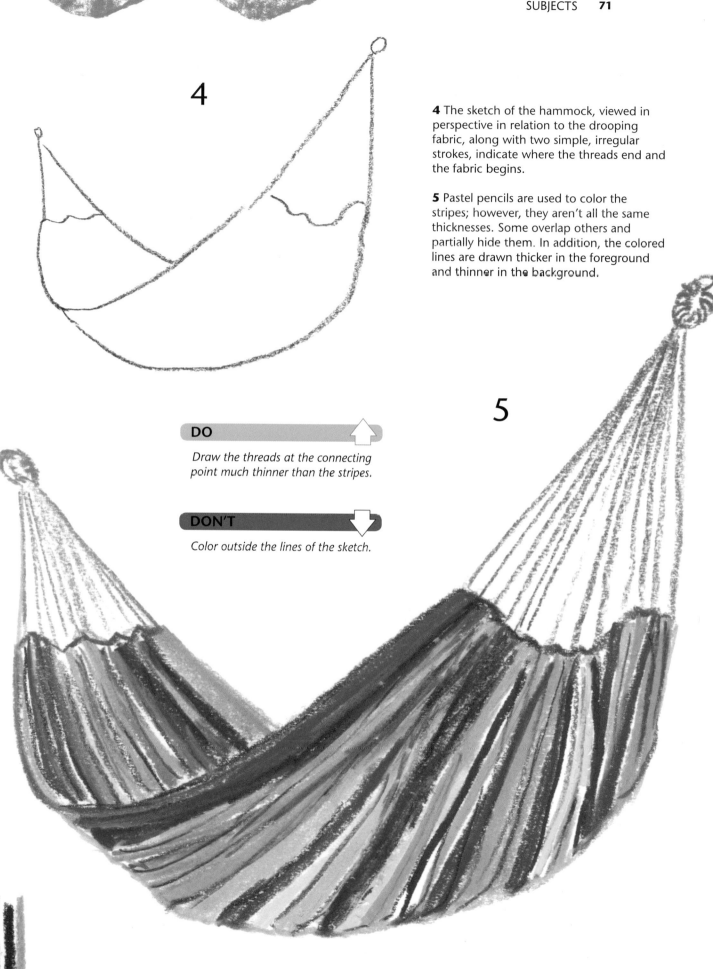

4

4 The sketch of the hammock, viewed in perspective in relation to the drooping fabric, along with two simple, irregular strokes, indicate where the threads end and the fabric begins.

5 Pastel pencils are used to color the stripes; however, they aren't all the same thicknesses. Some overlap others and partially hide them. In addition, the colored lines are drawn thicker in the foreground and thinner in the background.

DO

Draw the threads at the connecting point much thinner than the stripes.

DON'T

Color outside the lines of the sketch.

5

This close-up presents a very obvious vanishing point. In order to draw the basic sketch, you must first establish some of the distances. Study the distribution of all the pieces until you find a pattern, and draw the sketch on a separate piece of paper. Then draw the sketch onto your final paper, using light lines. Finally, shade in each area of the drawing with its corresponding tonal value. A graphite pencil is the ideal tool for this subject, because it offers a broad tonal range that, once applied to the drawing, will increase the sense of volume.

A Frontal View Close-up

1

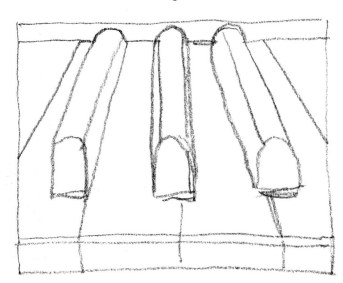

1 Draw the sketch on a separate piece of paper. You don't have to place the single vanishing point for this frontal perspective, as you can easily divide the partitions yourself. The drawing is approximately as tall as it is wide. One white key is twice as wide in the front as it is in the back. The width of a black key is half that of a white key. The black key in the middle is centered, and the two on each side begin at the edge of the white key.

2

2 In the sketch, place the important lines and note the tones for the areas. Use very light strokes with your graphite pencil. Don't indicate all the tones of every area; just summarize the most important ones.

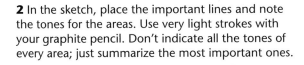

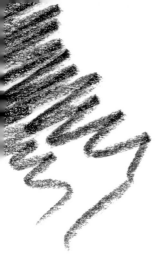

◀ A tonal range created with a graphite pencil will allow you to create contrasts and develop volumes.

3 Apply the appropriate shade to indicate different tones for different areas in the sketch. A tonal range will give it a greater sense of volume.

DO

Apply general shading, leaving the white keys blank.

DON'T

Shade all of it the same. Use the most intense tones for the black keys and the darkest areas.

3

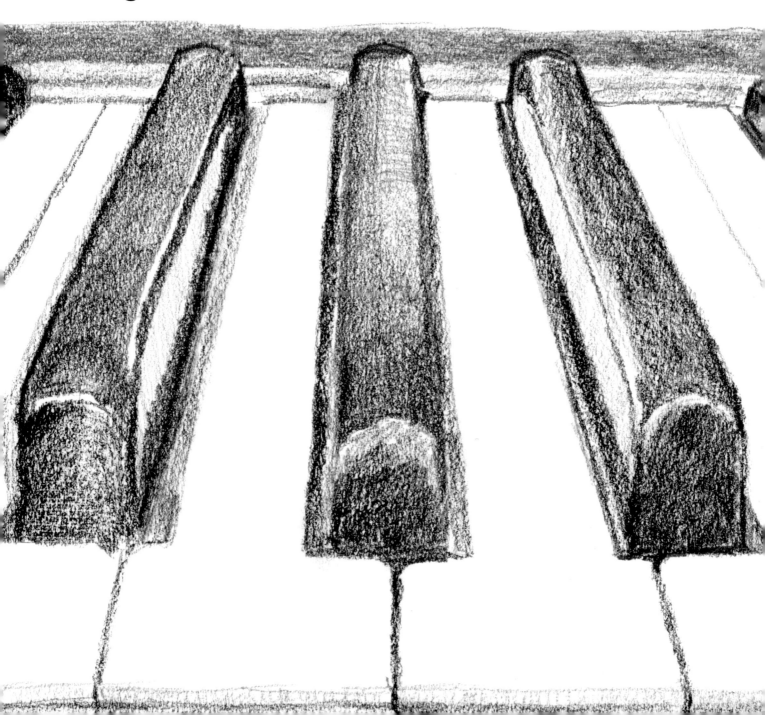

1

This awning and landscape, viewed in a close-up with just one vanishing point, has a very dynamic sense of depth. It's very easy to divide the space up. You must first decide where to place the awning and establish a simple relationship between the strips of the awning and the strips draping over the edge of the canvas. Sanguine is a great medium to convey volume in this composition, given its capacity for fading and smudging and the ease with which it allows you to create a variety of tones.

1 The canvas is centered in the drawing, a little underneath the vanishing point where the vanishing lines and the strips of the awning converge.

Awning in Perspective

Sanguine allows you to draw outlines and create different tones easily. To represent a landscape in the background with less concrete outlines than those in the foreground, all you have to do is smudge the details a bit with your finger.

2 The strips draping over the edge of the canvas are vertical. Each pair of vertical strips links two other strips of the awning. Four pairs of strips occupy the upper part of the awning, and the others fan open.

2

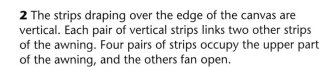

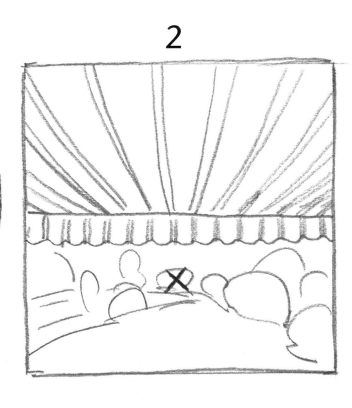

3 Draw the first half of the awning, placing the vertical strips and the load-bearing bar. Then begin to mark out the points that will let you locate the where the angled strips of the canvas will pass through. Sketch out a few simple outlines of the background landscape, and place the elements of the vegetation.

3

4 The landscape background will require a lot of smudging, using your fingertip, to create the necessary contrast with the close-up canvas, which hasn't been drawn yet.

4

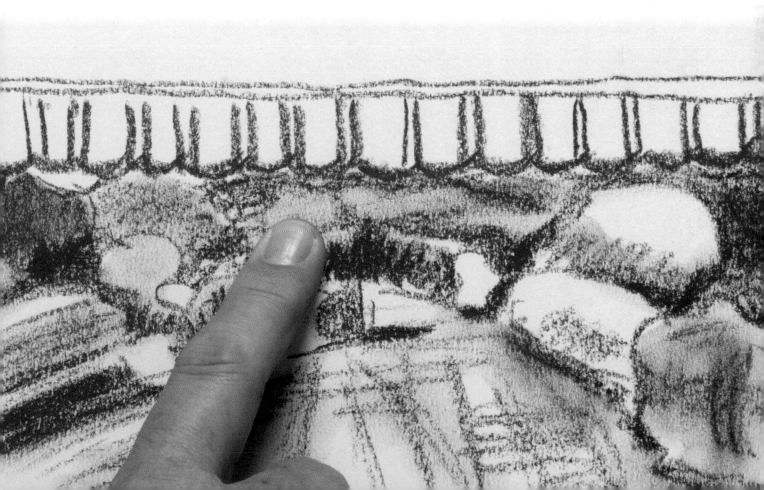

Framing emphasizes the vanishing lines

This framing of the subject produces a spectacular effect. It emphasizes that the strips of the canvas are very thick in the foreground and get thinner as you move farther away, until they are as thin as the vertical strips of the awning.

5 Four pairs of dark strips stretching into the distance occupy the upper part of the awning. The rest of them, also drawn darkly, are thinner and occupy the lateral upper parts of the drawing. They are thicker in the front and thinner at the back, broad in the middle and thin on the sides.

5

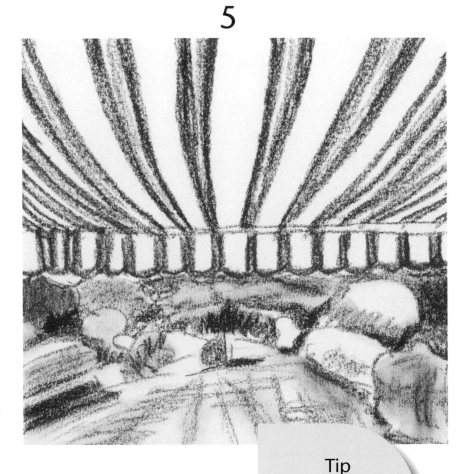

Tip
Give a certain curvature to the strips stretching into the background to indicate that the canvas is hanging down.

6

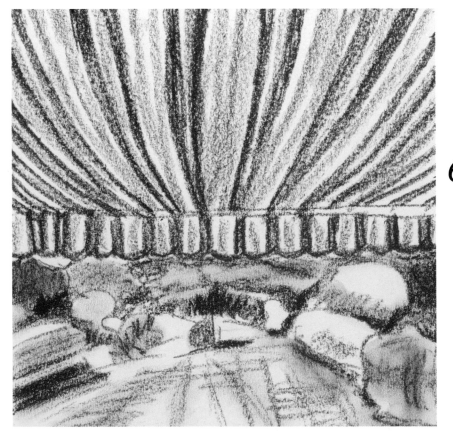

6 The lightest strips are easy to draw now, following the pattern of the darker ones.

7 To finish the drawing, add some final "tonal touches." With a dark shade of sanguine, reinforce the vertical strips of the awning and the strips of the canvas stretching into the distance. Add nuances to the landscape as well, to reinforce the sense of depth and make the awning stand out from the landscape.

7

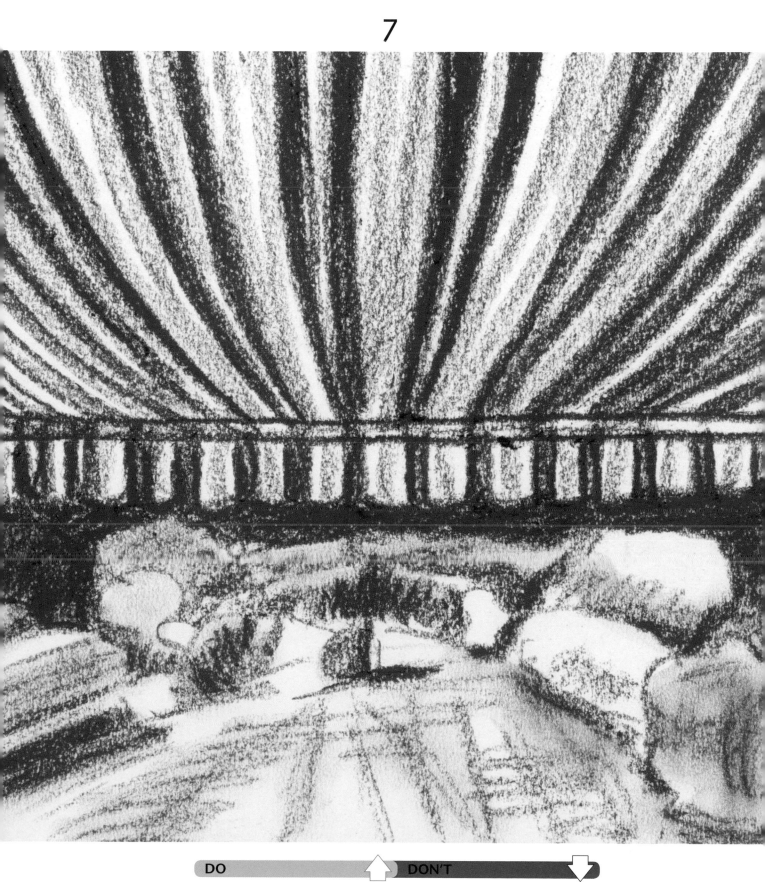

DO ⬆ **DON'T** ⬇

Smudge only the details in the landscape background.

Draw all the strips stretching into the background with the same thickness.

Most still life compositions contain elements that make it necessary to use a simple sketch to first establish perspective. To begin, set aside anything that doesn't need vanishing lines, and focus on the simple shape that needs perspective—the oblique view, in this example. Once the sketch has been drawn, you can add a few more lines to complete the rough draft of the drawing, with some minimal foreshortening in the curved lines.

1

1 Practice the basic sketch of this elongated shape on a separate sheet of paper. The sides of the box are not straight, as each side flares out and ends in a curved edge.

Still Life in Oblique Perspective

2

2 Draw the lemons and leaves in perspective. The shapes of the lemons range from oval to circular. The leaves are also drawn with a degree of foreshortening. In order to familiarize yourself with the foreshortening of these two shapes, practice sketching them on a separate sheet of paper.

◄ Charcoal sticks (A) and charcoal pencils (B) can create different fading and smudging effects.

3 Following the guidelines of the initial sketch, color the box. Use two tonal values corresponding to the lighting of the still life. Leave the lighter areas on the lemons and the leaves blank. In contrast, use darker values for the rest of the shapes.

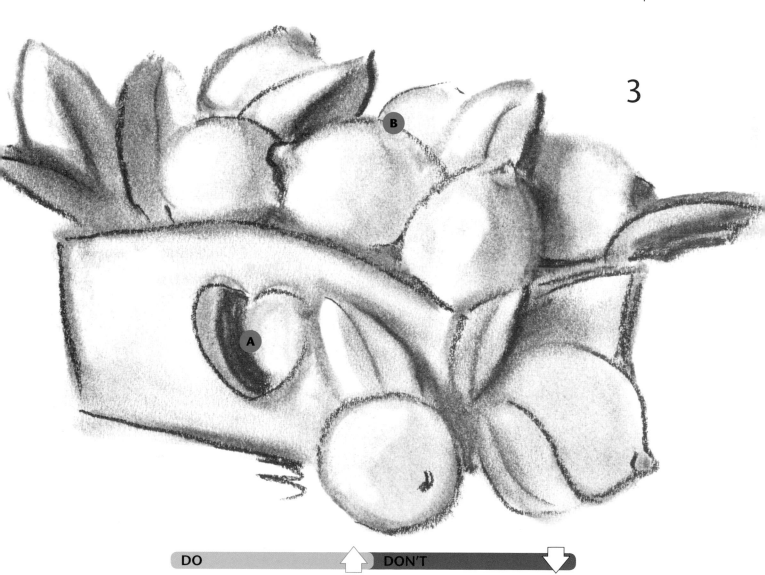

DO	DON'T
Decide where the light source is shining from before you begin shading.	Shade everything the same. There should be some areas that are lighter than others.

Highlighting the Oblique Perspective

Start the sketch using the basic shape of the subject. Then add a few more lines to define the details of the subject. This object is viewed from the oblique perspective, with a thick base that is smaller than its opening. Once you are familiarized with sketching the outline, select the color of paper to use for an attractive contrast in relation to charcoal and chalk. You will then be able to draw a finished, artistic sketch with just a few strokes. The tonal values here play a central role in making the drawing look realistic, thanks to the effect of shading on the subject and its reflections.

1 Draw the basic shape.

2 On the basic sketch, add a few more lines to characterize the object, with a base that is very thick and square-shaped but smaller than the opening, which is also square-shaped.

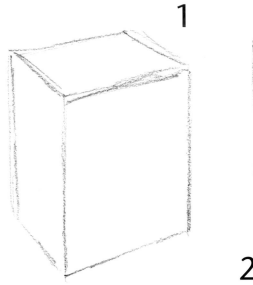

1

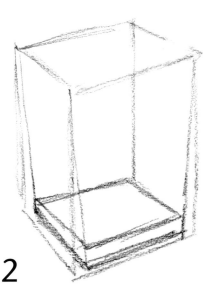

2

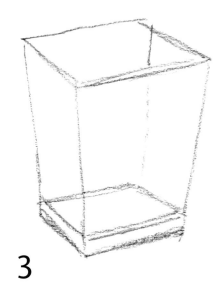

3

3 Get familiarized with the shape of the object, repeatedly sketching its outline without using the original as a reference.

4 To finish the sketch, draw a few lines to indicate the most relevant details of the subject.

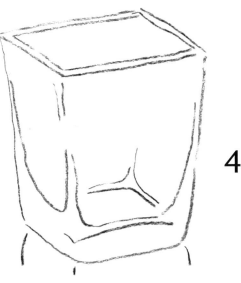

4

DO ⇧ **DON'T** ⇨

Practice the basic sketch of the subject on a separate piece of paper until you are familiarized with its shape.

Shade the highlighted areas; leave the paper blank here to apply white chalk later.

5

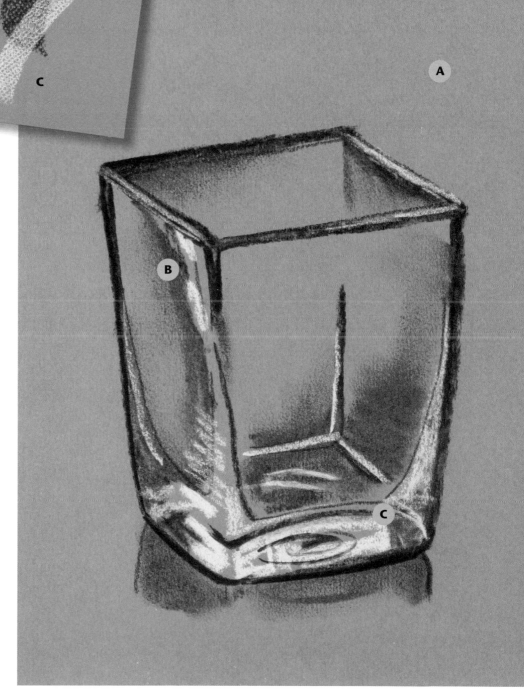

A The color of the paper is a defining factor that helps achieve attractive results.

B These smudges show the tonal range of charcoal and white chalk.

C The drawing shows how white chalk allows you to create interesting emphasis and gray mixes with smudging. These are the maximum highlights and give a nuanced perspective to the appearance of the glass.

5 The contrast of the charcoal on orange-colored paper is very vibrant. Lay out the most significant reflections on the object with strokes of white chalk. Sketch out the basic details, applying some shades of charcoal. This is an example that, while quite simple, will give you a strong, attractive drawing.

Mailbox in Perspective

1

To draw an open mailbox in oblique view, first you must figure out the general structure of the object and its specific shapes when it is closed. In this case, the shape of its opening is emphasized; with a simple line, you can easily depict the outline of the open door, drawing it as an open flap. To draw it in oblique perspective, use a charcoal stick, as it is one of the most effective media to represent volume quickly and easily.

1 It's easy to draw the general structure of the mailbox and establish its basic shapes. The arch shape takes up two-thirds of the vertical edge.

2 Draw the closed mailbox first. You don't even have to look at it for reference.

3 The visible base of the mailbox indicates two vanishing lines. Stretch the longest one out to the left of the drawing. To finish the drawing, keep in mind that the foreshortened open flap is shorter than the height of the mailbox's opening.

2

3

▶ It's easy to smudge strokes of charcoal to create shadows that you can fade to better indicate volume.

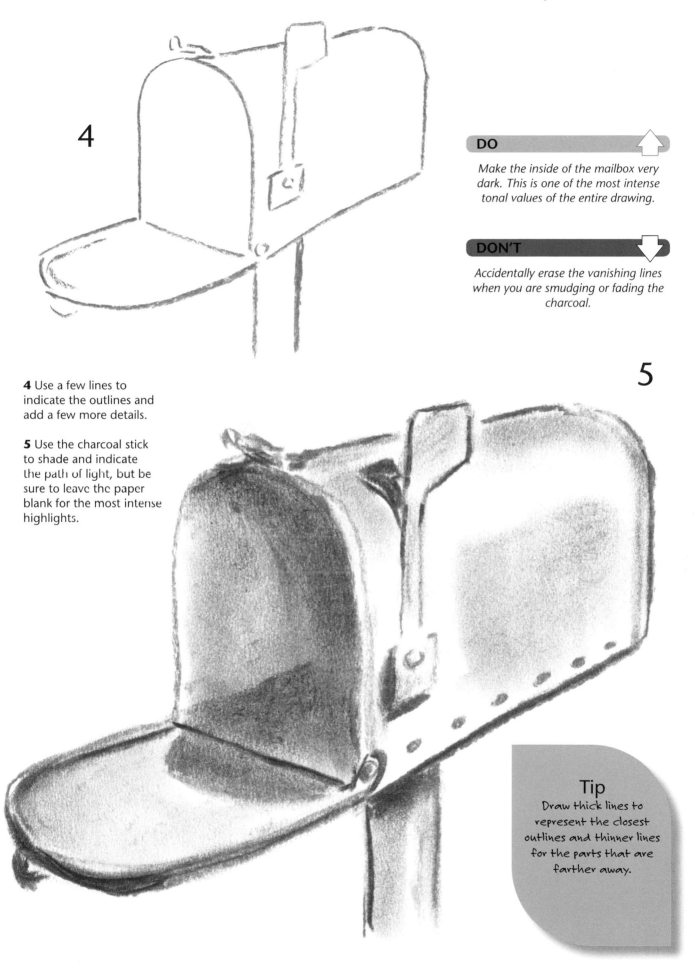

4

DO

Make the inside of the mailbox very dark. This is one of the most intense tonal values of the entire drawing.

DON'T

Accidentally erase the vanishing lines when you are smudging or fading the charcoal.

4 Use a few lines to indicate the outlines and add a few more details.

5 Use the charcoal stick to shade and indicate the path of light, but be sure to leave the paper blank for the most intense highlights.

5

Tip

Draw thick lines to represent the closest outlines and thinner lines for the parts that are farther away.

This example provides an aerial perspective and only requires you to place three vanishing lines on the paper. You don't even need to measure them; you can simply eyeball them to establish their relationships and distances. You can draw the rest of the lines in the drawing between these three lines, which converge on a vanishing point located somewhere to the left. The remaining lines will be a series of parallel shapes that are slightly tilted, in relation to the vertical lines. These lines converge on the second vanishing point, located somewhere to the right. With these two series of lines, you can define the outline of each object. Not all of lines are equal, and you will give them individual variations and characteristics.

A

Sketching with Vanishing Lines

A The basic sketch is very simple. It is made up of just one diagonal line and two converging lines—you can eyeball these three lines—and the remaining vanishing lines.

B The subject, viewed from aerial perspective, can be drawn in two steps. The first step is to sketch the outside cover.

C The second step involves adding a few more lines to describe the interior of the subject.

D You will use two tones to indicate the direction of the light source. The brightest tone is used for the areas in light, and the darkest tone is for the shadows. Use gray to represent the shadow of the books' pages.

B

C

D

▶ Use colored pencil to draw lines and practice coloring in layers.

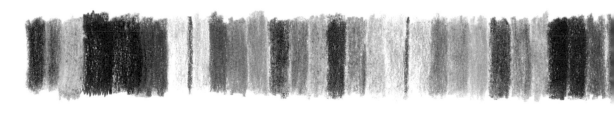

The books should not all be drawn the same. Some of them should stick out more than others, some taller, some thicker. However, all of them should respect the general sketch, as well as the general principle: "closer objects are drawn larger, and the farther away they are, the smaller they get."

Tip

Color the drawing with strokes that follow the direction of the vanishing lines. This will help define the structure of the entire drawing.

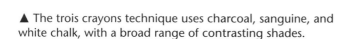

▲ The trois crayons technique uses charcoal, sanguine, and white chalk, with a broad range of contrasting shades.

Aerial View

Aerial view does not always require three vanishing points. In this case, the drawing is simplified due to the flat element of the cobblestones. Locate two groups of vanishing lines. The two vanishing points, which are located very far away, indicate their general direction. Then add depth with shading. The trois crayons technique gives a sense of depth to a scene that initially might appear to be flat. All you have to do is shade and color the objects in this example.

A

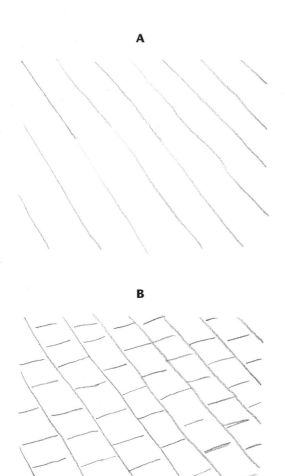

B

A With a pronounced aerial view, depict the first series of converging lines.

B The second series of converging lines describes the shape of the stone walkway.

C Use a series of curves to indicate the leaves. This element, with its curved angles and contours, creates contrast with the straight lines of the cobblestones.

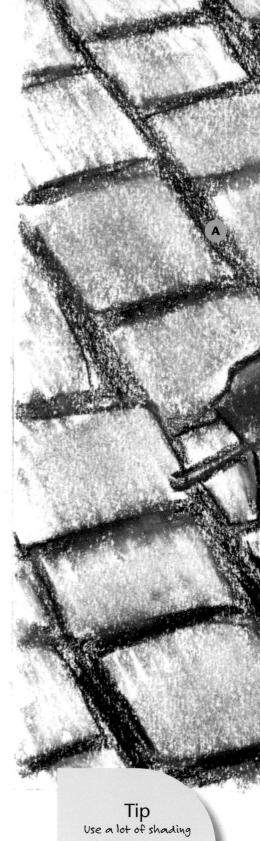

Tip
Use a lot of shading at intersecting points, but don't draw in any random direction. Your strokes should always follow the direction of the vanishing lines.

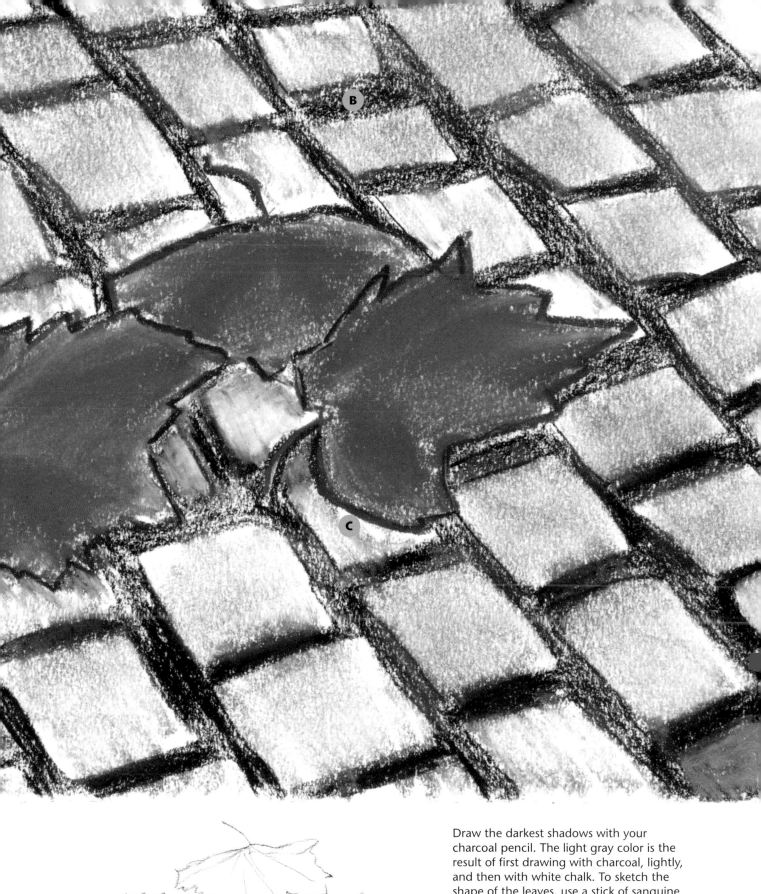

Draw the darkest shadows with your charcoal pencil. The light gray color is the result of first drawing with charcoal, lightly, and then with white chalk. To sketch the shape of the leaves, use a stick of sanguine and a stick of white chalk.

Scene with Various Planes

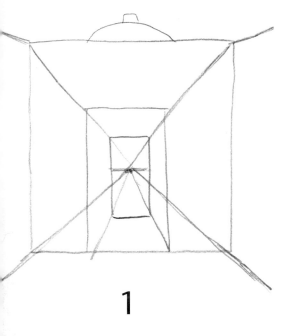

1

The following example is an urban scene involving clearly differentiated planes involving just one vanishing point. A few more lines are placed in the scene to locate the different planes and the most important elements of the scene. In the sketch, use simple marks and light strokes to sketch out some of the objects that represent the foreground. Once all the different planes are established, you can start to shade the drawing. Remember that graphite pencils are one of the best media to represent different planes due to their broad range of tones and fading capabilities.

1 The vanishing point is located above the horizon line in the background, where the ocean meets the sky.

2 Draw the sketch with light lines.

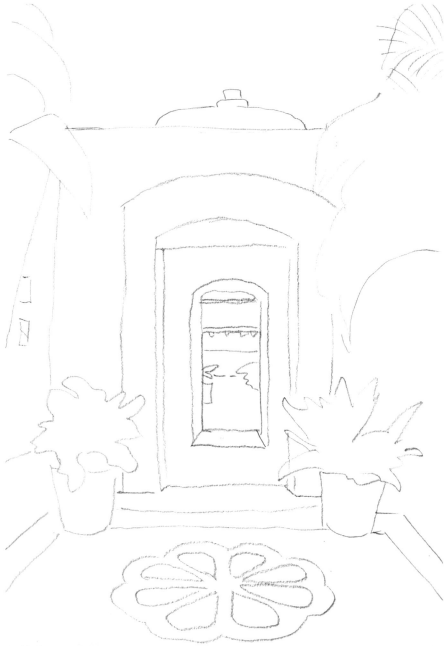

2

3

3 First shade the sky to obtain a hazy look. Scratch some graphite dust off of the stick, and spread it across the area with your finger until it smudges properly.

4 Shade the planes of the middle ground.

▼ A 2HB graphite pencil and a 6B stick will obtain rich nuances and contrasts between shadows and will also allow you to smudge the graphite for shading.

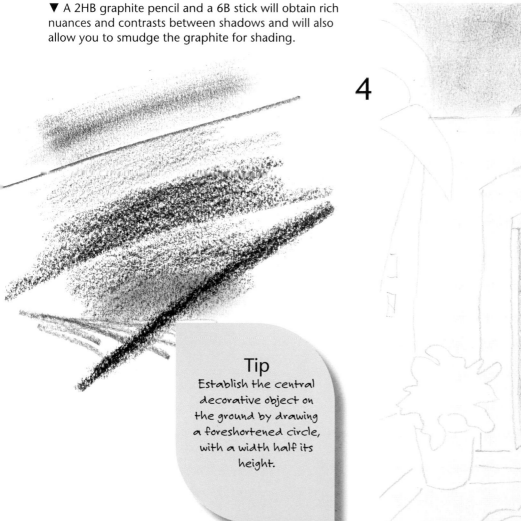

4

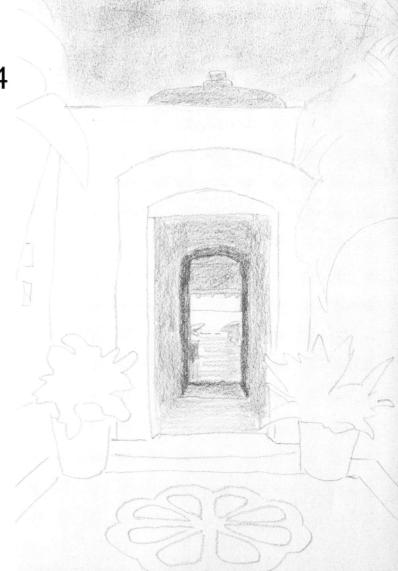

Tip
Establish the central decorative object on the ground by drawing a foreshortened circle, with a width half its height.

Contrast between planes

Where different planes are distinguished, it's important not to shade everything with the same intensity, as this will give the drawing a flat look. Rather, smudge the planes that are the farthest away to represent the sky, and make sure to contrast the closest planes to create depth.

5

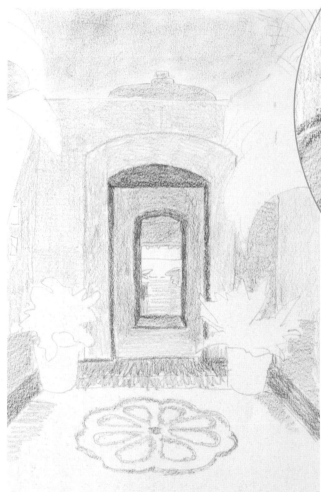

6

5 For the shading in the foreground, use different tones to differentiate between the areas in light and shadow.

6 Start by defining the elements of the vegetation. Use the graphite bar to shade the foreground, as it will allow you to obtain intense tones that nicely contrast with the lighter tones.

7 To establish consistent values throughout the composition, you must touch up and darken some of the tones. Work on a few specific details, smudging the graphite in certain areas; this will help you define the palm trees, for instance.

DO

Properly distinguish the transitions from one plane to another to better represent perspective.

DON'T

Drag your hand across the drawing when shading, or you will smudge it by accident.

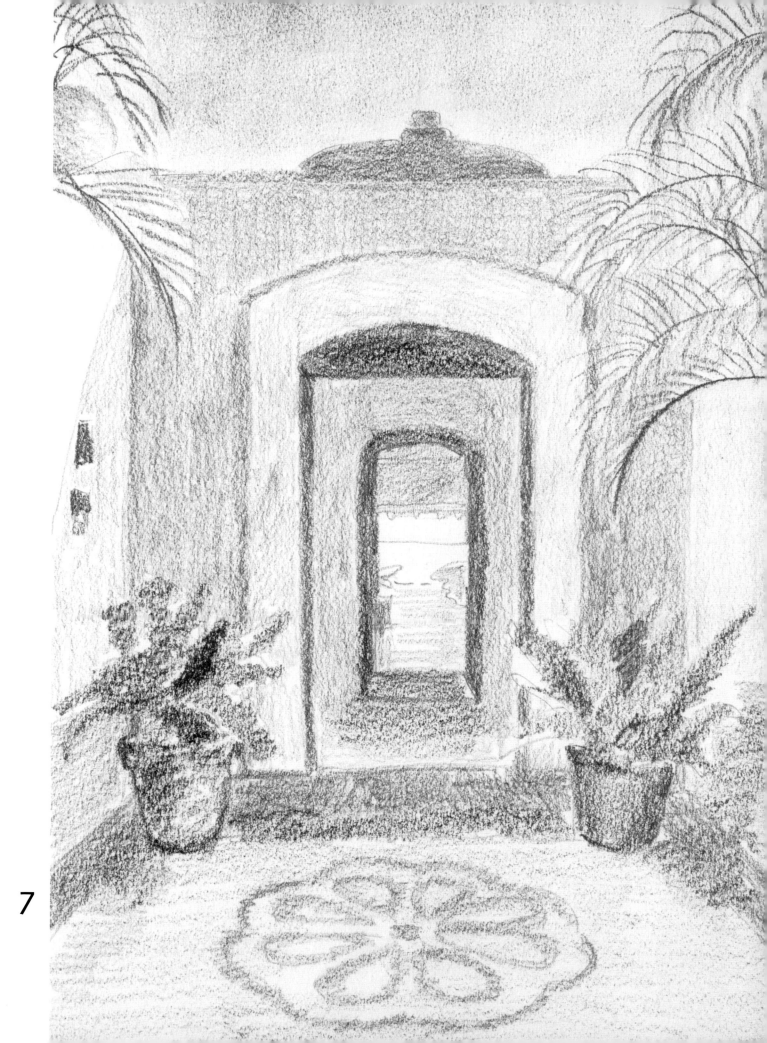

7

Perspective in a Flat Drawing

This still life drawing represents a great close-up scene. Create the sketch based on simple shapes, with just one vanishing point. In fact, think of it in terms of various planes, each of which contains different groups of elements: the extreme foreground, the large group in the middle ground framed by the rectangle in perspective, and the background. In this example, learn to use perspective without trying to draw a composition with a lot of depth. The main goal here is to give the drawing a plastic, decorative effect.

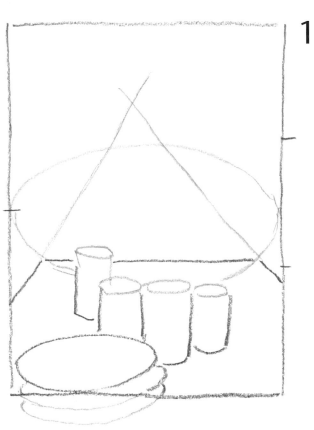

1

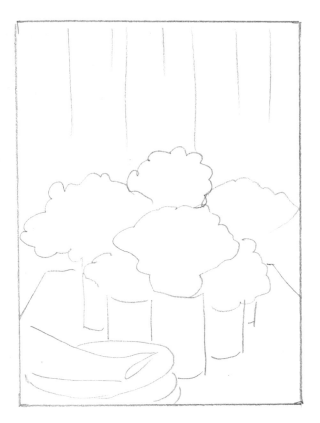

2

The colors of the pastel sticks provide a strong contrast with the blue paper, especially due to the paper's rough grain.

1 Place all the elements in the composition, as well as the vanishing point, with a simple sketch involving only a few lines and shapes. The line at the bottom of the table is one third the total height of the drawing. The collection of flowers is in the center.

2 Just a little sketching will place all the important elements in the drawing: the table, plates, and vases. Draw a lot of flattened circles and the edge of the table. The group of flowers is included in a centered oval-shaped sketch, at a midpoint in the drawing. The table, meanwhile, occupies the lower third of the drawing.

3

3 Use perspective with the curved strokes for the plates in the foreground and to place the upper part of the table. Color the group of vases vertically, and finish them off with some flowers that have large, colored patches. Lightly indicate the curtains in the background.

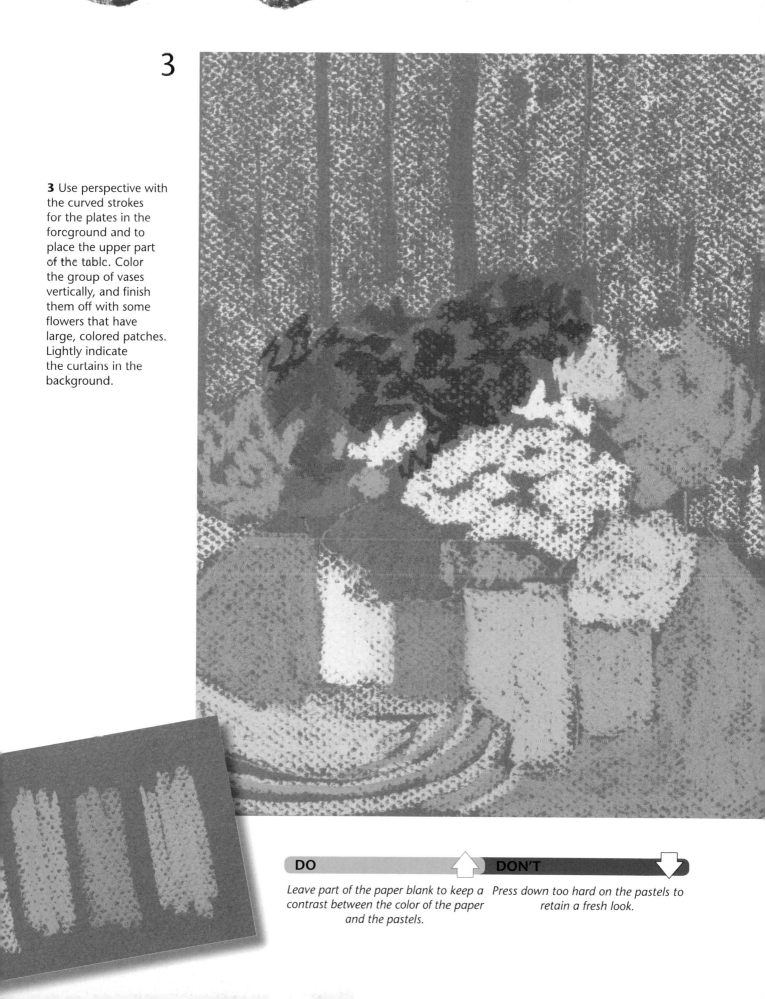

DO ⬆ **DON'T** ⬇

Leave part of the paper blank to keep a contrast between the color of the paper and the pastels.

Press down too hard on the pastels to retain a fresh look.

Straight & Curved Lines in Oblique Perspective

This drawing is based on a combination of straight and curved lines. The straight lines correspond to vanishing lines with an oblique perspective, which are simplified by using just one vanishing point. The idea is to divide the space with a series of lines that converge to the right, and locate the rest of the objects among those lines, keeping the same vanishing point. First, place the upper and lower vanishing lines. For the remaining lines and the combination of objects, you can draw them simply with just a few simple observations.

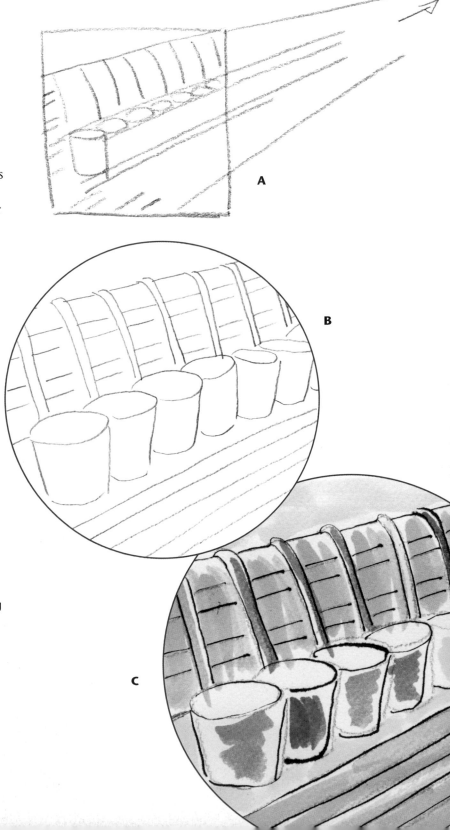

A

B

C

A This simple sketch divides the drawing up with a series of lines that converge at the same vanishing point. The box shows how to frame the drawing.

B Draw the sketch lightly with a graphite pencil.

C Before starting the final drawing, test out a few effects on sketch paper to check the colors of ink you've chosen. Once everything is dry, erase the pencil marks with an eraser.

D This exercise, based on one vanishing point, makes it easy to outline the sketch with your pen nib and then add ink with your brush. The second wash can be applied once the first is completely dry.

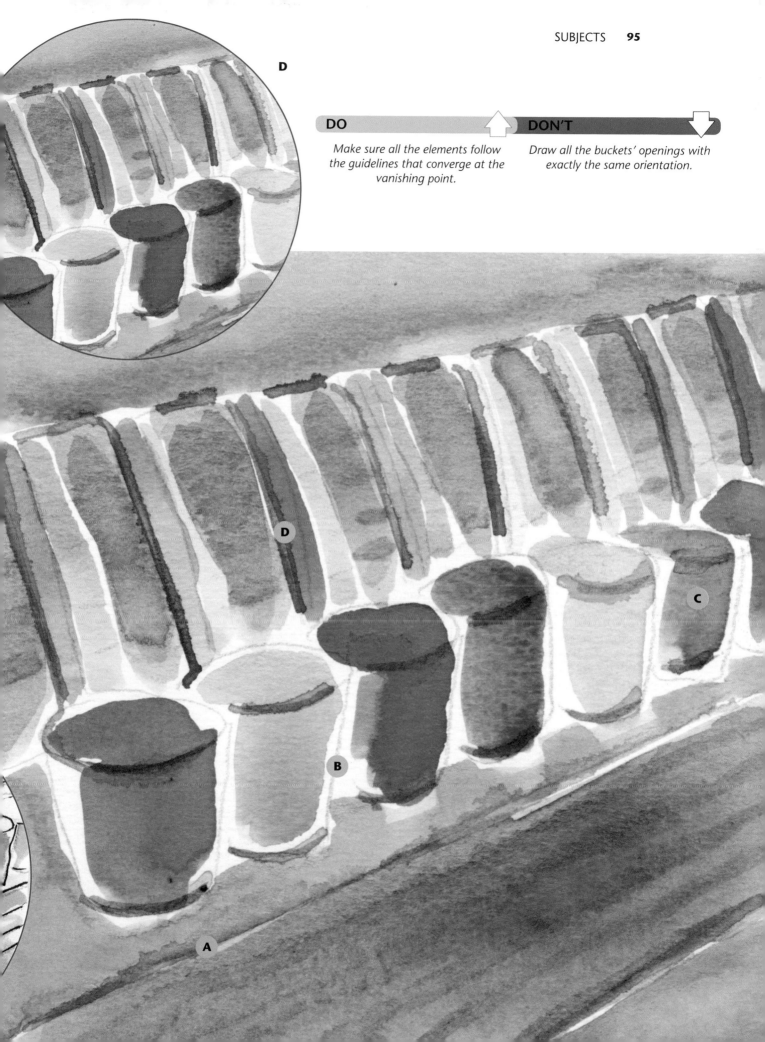

DO **DON'T**

Make sure all the elements follow the guidelines that converge at the vanishing point.

Draw all the buckets' openings with exactly the same orientation.

The reflection of a landscape on water is an element that will enrich any drawing. Two-point perspective is used here, since this drawing involves an oblique view; however, this perspective can be simplified to work with just one vanishing point. Three basic vanishing lines divide the drawing. The sky, the buildings, the dock, and the reflection of the buildings on the water each have well-defined sectors. The sections are then further divided with vertical strips.

A

Landscape with Reflection in Perspective

B

A Draw the sketch based on the vanishing lines, adding in a few more details.

B A charcoal pencil will allow you to draw quickly, with strokes and shading that you can smudge and fade. By shading the sketch, you'll create a drawing that feels fresh and alive.

C You can partially recover some of the color of the paper by erasing the charcoal shading and smudging it with your finger.

C

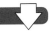

DO

Make sure the reflection of the buildings starts underneath the dock, remembering that it only includes the tops of the buildings.

DON'T

Forget the proportions between the windows and doors and the height and width of the buildings.

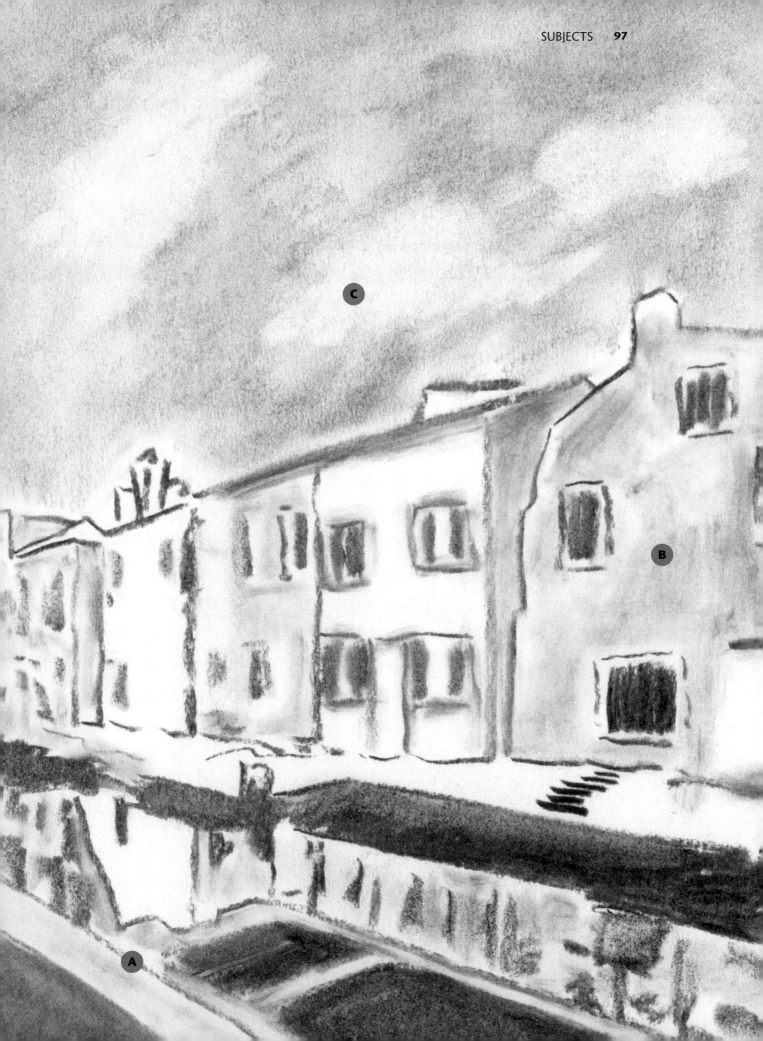

Perspective in an Interior Scene

This interior scene, which contains several objects, contains an important line indicating where the floor ends and the wall begins. This line divides the drawing in two. The top part is the background; all of the objects should be drawn on the bottom part. The upper part of the table appears as a straight line, and all the curves of the vases and the base of the end table are drawn convex on the top and concave on the bottom. Draw the objects with the most oblique view separately. Finally, sketch the scene onto your final paper and add shading, which will give the composition depth.

1 Sketch the object seen in oblique view separately.

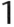

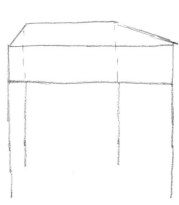

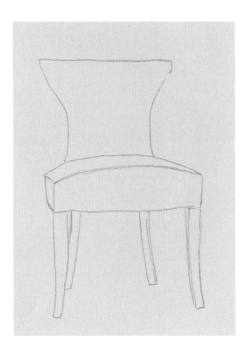

2 This basic sketch will make it easier for you to finish the complete sketch.

3 The first sketch of this interior scene contains mostly frontal view elements, with one oblique object to provide some variety in the scene.

4 By shading the sketch, you will turn a "flat" scene into a drawing with a real sense of depth.

▶ Use two pencils to develop all of the necessary tones: a 2HB and a 6B. Graphite pencil is helpful for working on outlines and shading in tones.

3

Make sure the line where the background plane begins is placed far back enough for all of the elements in the room to be grounded.

Shade in the areas in light. Try to mentally block them off before you begin shading.

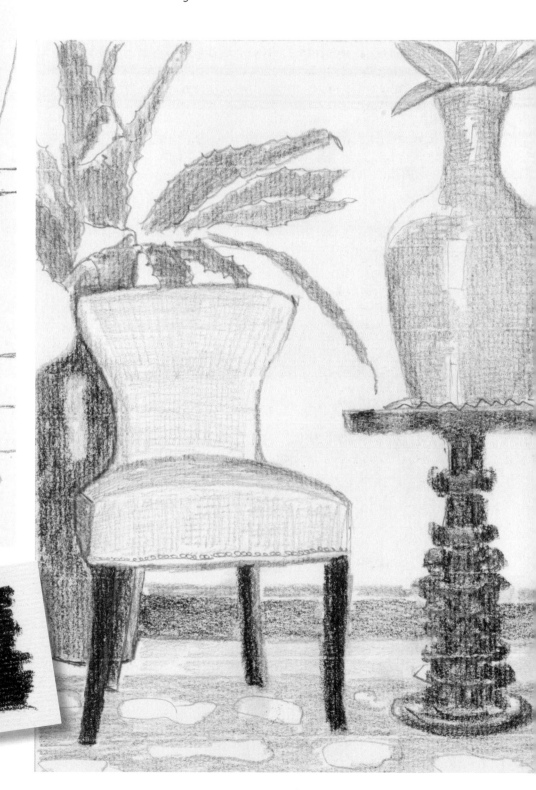

4

The latticework in the background has a slightly oblique view, and its structure is quite easy to draw. However, before sketching the general structure, use a piece of scratch paper to make some brief strokes and study the shape of the pot until you are able to properly depict it. You will have to make a few modifications to make it fit perfectly as a hanging potted plant. To place it in the sketch, use a few reference points: the pot and the flowers are hanging in front of the latticework in the center of the drawing.

1

Foreshortened Flowerpot

2

1 Draw the general contours of the pot.

2 Develop the characteristic shape of the subject.

3 The structure of the latticework presents an oblique perspective, developed with one vanishing point. The hanging pot offers a different point of view—a somewhat aerial one— and can be described with a few less-flattened shapes. The pot is centered in the lower part of the drawing, with the flowers above in the center of the drawing. The latticework, which is taller than it is wide, occupies the left half of the drawing.

Tip
Shade the latticework on the wall with two contrasting gray tones.

3

Colored pencils will give you a very broad range, allowing you to apply the exact shades of color without mixing.

► Step-by-step sequence for drawing a flower.

▼ A flower can be viewed from a variety of foreshortened perspectives. The drawing will look more interesting if you represent the flowers in varying positions.

4 To add depth, color the drawing systematically to represent the shadows. There are shadows on the wall cast by the latticework, the pot, and the flowers. There are also shadows between the different elements of the latticework and the pot. The combination of the flowers and pot casts a large shadow on the wall.

 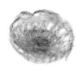

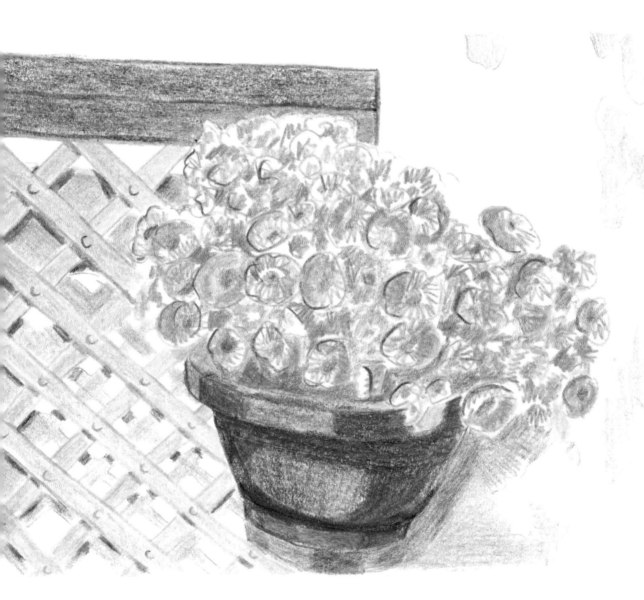

DO ⬆ **DON'T** ⬇ **4**

Be mindful of the light source and the direction from which it shines. *Draw all the flowers with the same outline.*

Urban Perspective

In an urban scene, you may need to draw some elements in the foreground that require you to pay closer attention to perspective. These are typically elements that make up any ordinary cityscape, and it's important to draw them correctly. Develop the basic sketch, and once the general elements have been sketched out, you can then sketch out the simple outline of the objects in the foreground of the drawing. Using ink with a brush, you can gradually introduce values to the drawing and further develop the outlines of the essential elements.

1 The foreground is in the center of the drawing, leaving more or less the same amount of space around all four edges of the drawing.

2 To draw the planter, consider it as part of a sphere. The edge of the planter starts below the midpoint of the sphere, and its opening is beneath the sphere's center. Draw the edge of the planter's mouth, following the circumference of the flattened circle.

▼ Water lightens the tone of ink and makes it easy to create a very broad range of shades. You can obtain even more shades by painting a second wash over patches of dry ink. An extra-fine brush will allow you to draw defined outlines, while a thick brush is ideal for painting large patches.

3 First apply the lightest tones, brushstroke by brushstroke. The tone used for the background must be very light to contrast with the foreground, which should be more intense. The tone of the brushstrokes should become more intense as you move into the shaded areas.

DO ⬆

Set aside parts of the paper for the areas in the brightest light.

DON'T ⬇

Use intense tones for the background.

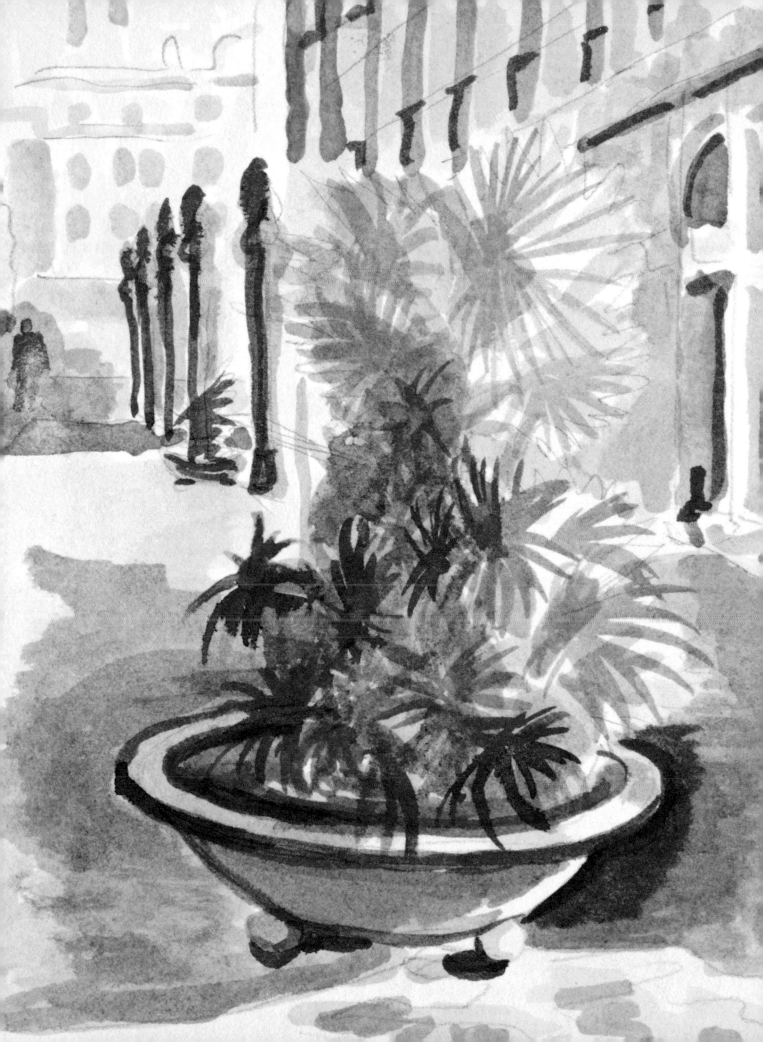

In this urban scene, the converging vanishing lines are easy to locate. The phone booths are lined up in a row, and they all have regular shapes. The first step is to develop the basic sketch of the closest booth in oblique perspective. This sketch shows the tilt of the vanishing line along its base and suggests the angle of the other booths. For your final drawing, draw the sketch, drawing each outline with its corresponding color. Use two pastel pencils, one gray and one red.

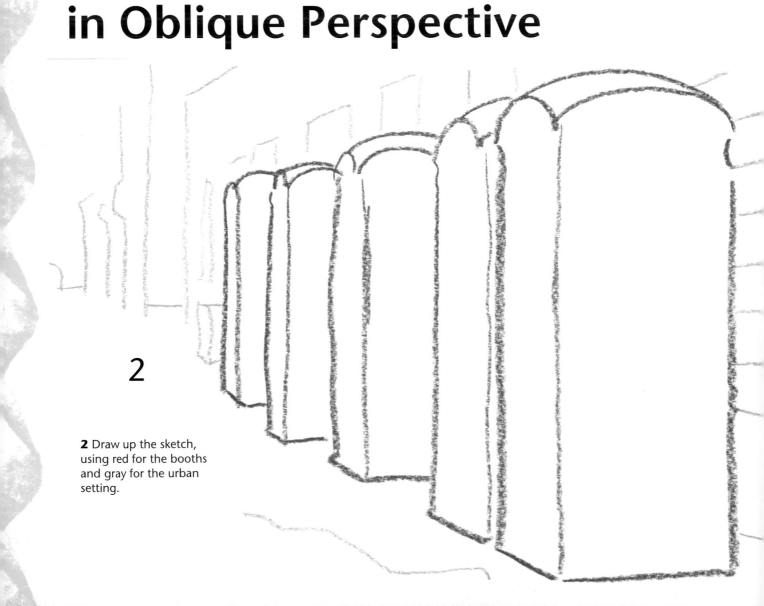

1 Create a series of lines that converge into one vanishing point. Draw the base of the closest booth, and try to envision the position of the second vanishing point, although it is very far away.

Phone Booths in Oblique Perspective

2 Draw up the sketch, using red for the booths and gray for the urban setting.

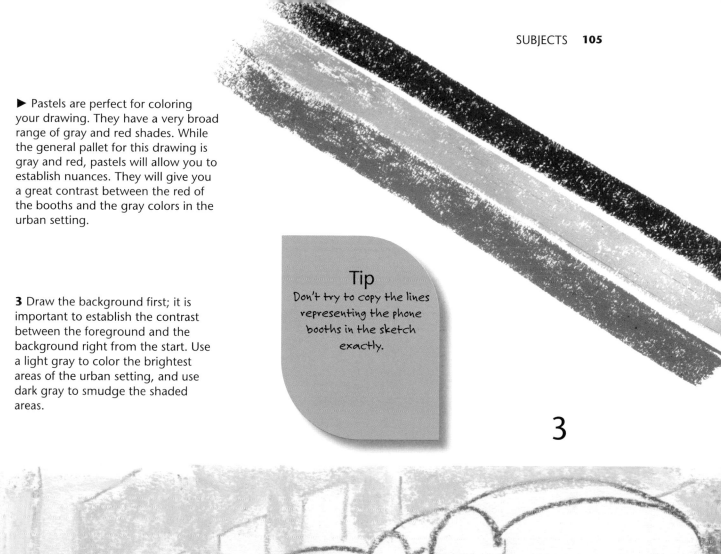

► Pastels are perfect for coloring your drawing. They have a very broad range of gray and red shades. While the general pallet for this drawing is gray and red, pastels will allow you to establish nuances. They will give you a great contrast between the red of the booths and the gray colors in the urban setting.

3 Draw the background first; it is important to establish the contrast between the foreground and the background right from the start. Use a light gray to color the brightest areas of the urban setting, and use dark gray to smudge the shaded areas.

Tip
Don't try to copy the lines representing the phone booths in the sketch exactly.

3

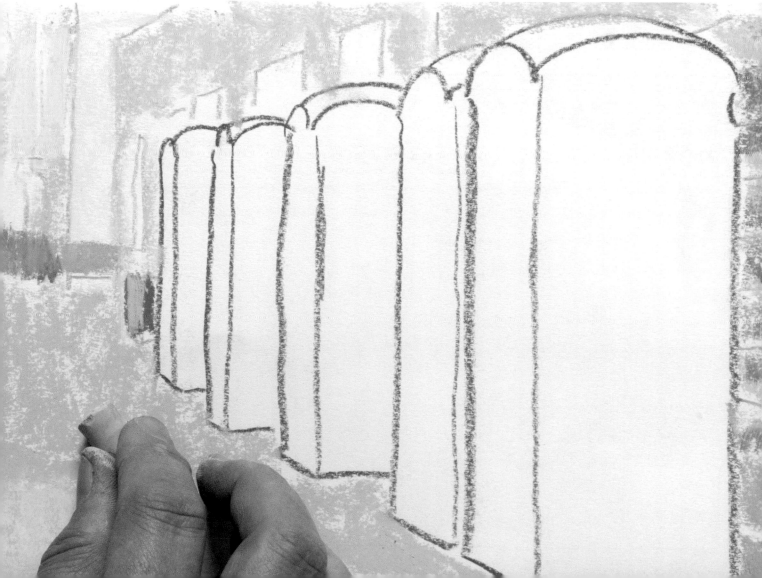

The right contrasts

At this point, evaluate the drawing to make sure there is enough contrast between the outlines, the colors in the foreground, and the shading of the other planes. This is the time to fade or smudge the colors until you get the right degree of contrast. Use your fingertip to smudge the pastel as much as necessary. If you need to remove some color, you can rub the pastel with a cotton cloth.

4

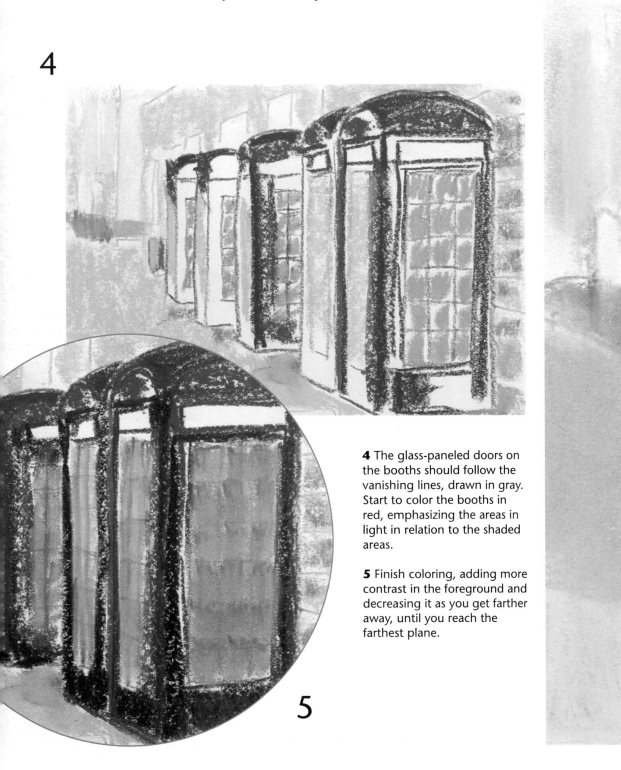

5

4 The glass-paneled doors on the booths should follow the vanishing lines, drawn in gray. Start to color the booths in red, emphasizing the areas in light in relation to the shaded areas.

5 Finish coloring, adding more contrast in the foreground and decreasing it as you get farther away, until you reach the farthest plane.

6 Smudging allows you to evaluate the contrasts, giving the drawing greater depth.

Give the details in the foreground the most depth, but make sure the details are more blended in the background, where contrasts can sometimes disappear entirely.

Go outside of the lines when you color. It might accidentally distort the shape of your subjects.

6

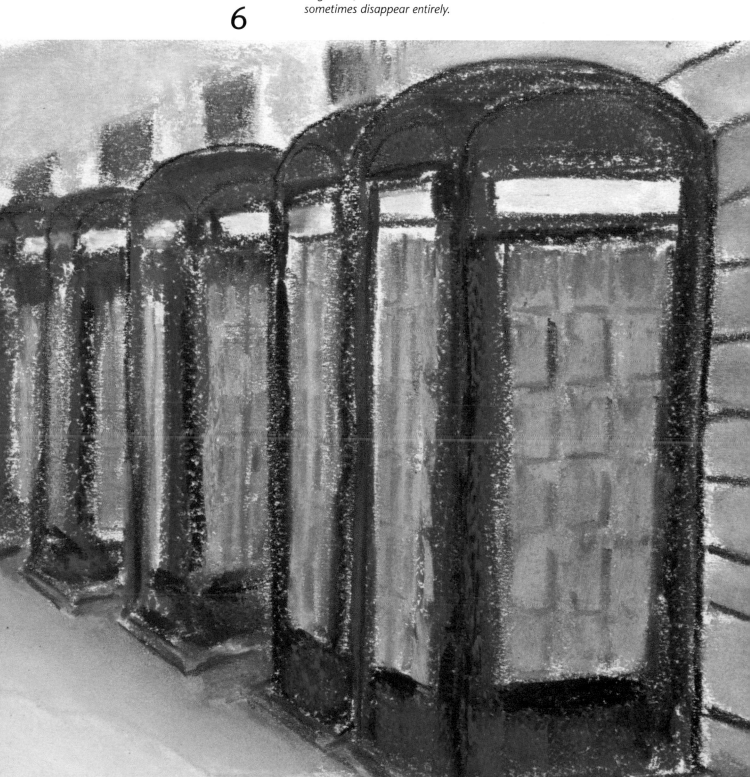

Tiles in Perspective

A tiled floor is a very common element of an interior setting. In this frontal-view exercise, you will learn to draw the main lines to correctly distribute the tiles and their decorative elements. Draw the sketch based on a point of view with one vanishing point. The basic sketch already begins to create a sense of depth. However, once you apply color, the sanguine technique will increase the effect, combined with sepia and white chalk for added detail and highlights.

1

Tip
Keep perspective in mind. Draw the tiles of the first line in the foreground wider than their height.

1 The sketch is easy to develop. Remember that the distance between each row of tiles should become narrower and narrower as they recede. This will make the sense of depth readily apparent.

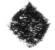

▲ The design of the tiles is quite simple—there is a colored square in each corner. To draw the detail, color a flattened rhombus that includes all four corners.

2 Place the rhombuses along the vanishing line, and draw each rhombus smaller and more flattened as the rows recede. Their tone should become lighter and lighter as they get farter away, to create a better contrast. Color them with sanguine and a touch of white chalk.

2

DO

Select tiles with simple designs, to give the drawing a defined look.

DON'T

Frame the drawing in a forced way that makes the tiles in the foreground look like they have an aerial view.

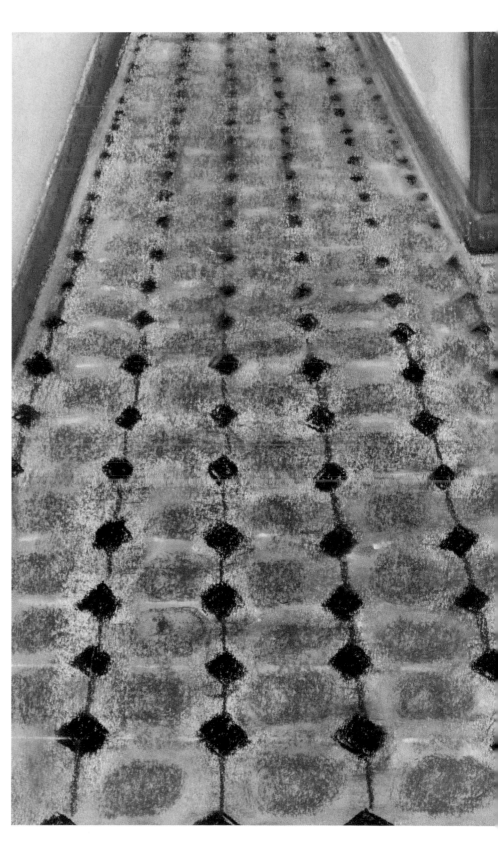

On a wall with overlapping elements, it is essential to draw the vanishing lines based on a vanishing point that connects all the elements. The main elements in this drawing require a second vanishing point. Although both points are located off of the paper, you must place a couple of lines that converge on each vanishing point. This will give you an approximate idea of where to locate the horizon line and the distance the two vanishing points should be from each other. With your graphite pencil, draw the simple shapes representing the objects in the drawing and shade with a range of tones on the white paper.

▲ Graphite is the ideal media for representing shadows, providing many different tonal values to add volume to all of the objects in the drawing.

Interior with Oblique View

1 Put the sketch together with just a few strokes that show the two series of vanishing lines. Everything is quite centered on the paper, although the view is oblique.

2 Once the general lines are drawn, it is easy to establish and place the rest of the objects by following their guidelines. For instance, the objects on the shelves are drawn in the same direction as the shelves, but on a reduced scale, and the reflection in the mirror should match the object it is reflecting.

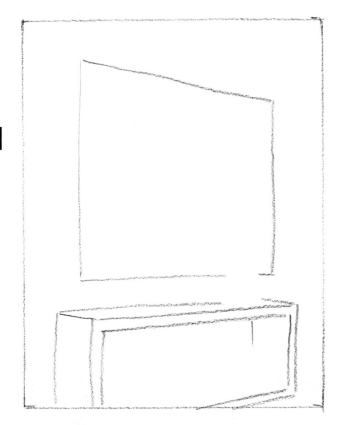

1

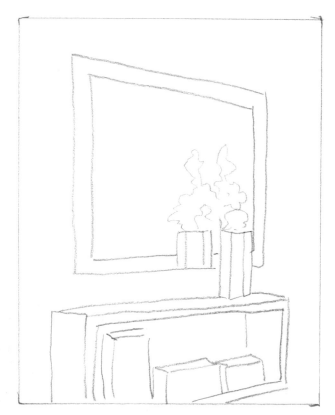

2

3 It's evident that, when applying the tonal range for this interior scene, you will achieve a great sense of depth. Try to contrast the areas in light and the areas in shadow.

DO

Have a good idea of where to place the brightest highlights of the drawing, and leave those areas blank.

DON'T

Shade everything with the same intensity. You should be able to add depth with just a few shades.

3

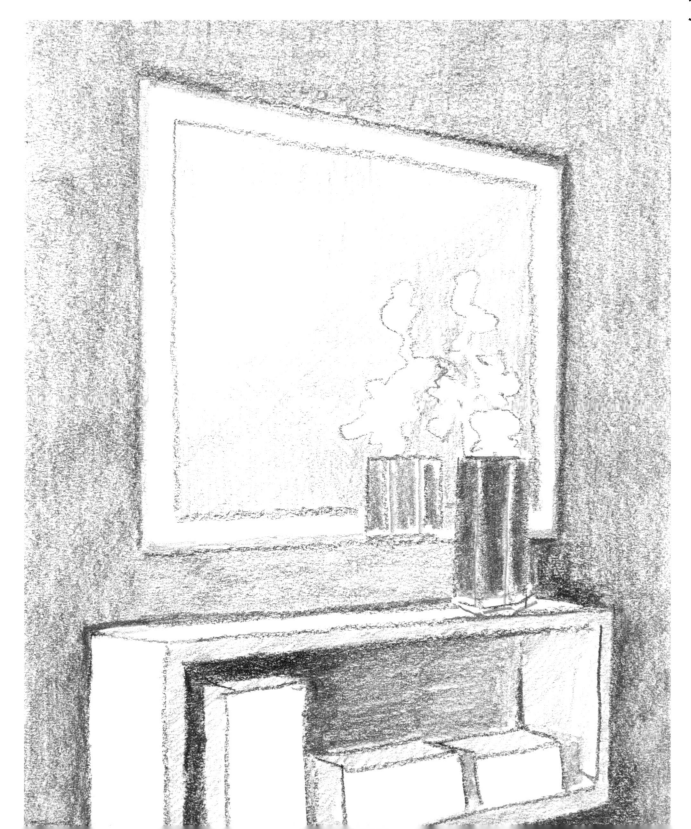

Hatching, Shading & Perspective

The following exercise will show how to apply hatching to create a stronger sense of perspective. Although this is a frontal view, there are several elements that can give depth to your composition, including the foreground and its vanishing lines and the several objects that stand out in the background with cast shadows. Always keep in mind the direction of light when shading. Hatching gives character to each of the distinct elements in the drawing and will help you to achieve a greater sense of depth.

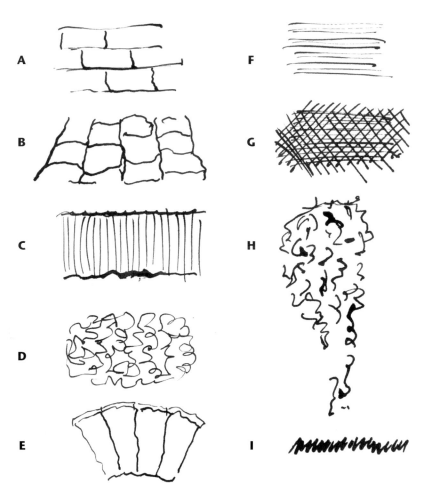

A Use this hatch to represent the bricks on the side of the building.

B Create a detailed pattern for the cobblestone walkway in the foreground.

C This vertical hatch represents the hanging curtains.

D Use an undefined pattern to represent vegetation; can be used for the flowers in the planter.

E A curved hatch represents the stones that configure the arch of the window.

F The blinds behind the window are a series of horizontal hatches.

G A series of overlapping linear hatches create the darkest areas of the windows (representing the interior of the house).

H This hatch should emphasize hanging foliage.

I Use a short hatch to suggest the shadow of an overhang.

1

1 With a subject in full frontal view, the sketch is quite easy.

2 When hatching, work with a pen nib to describe all of the elements. The stone walkway in the foreground, for instance, is very detailed.

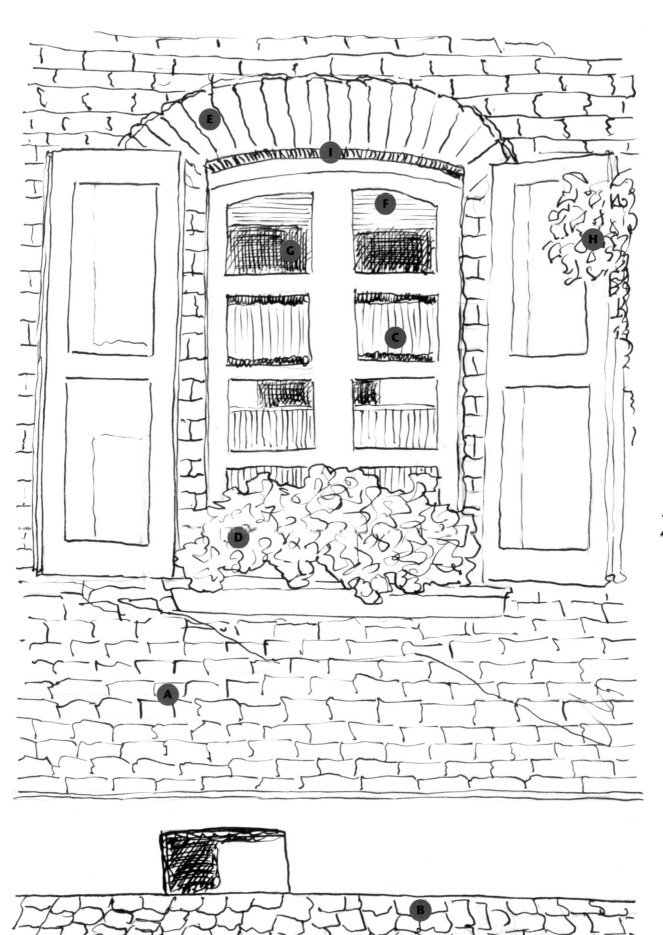

2

Hatched shadows

The patterns that describe the characteristics of each element in your drawing—the direction of their vanishing lines, their texture, the way they hang—can also be supplemented with other hatching to represent cast shadows. In this exercise, draw the hatching for shadows based on a series of parallel lines. The most important angle should correspond to the direction of the cast shadow. Draw another series of parallel, vertical, and horizontal lines across this first series of lines, until you obtain the desired level of contrast.

DO

Analyze the best hatch to represent each element.

DON'T

Draw the shadows too intensely, as this will make the drawing look too defined.

3 Using lighter ink, shade another series of hatching lines, and observe how some elements appear to pop from the background.

4 Basically, you have two overarching shadows: the shadow cast by the window shutters and the shadow cast by the flower planter. These hatches are drawn with series of parallel lines; one series corresponds with the direction of the cast shadow, and the second is vertical. A third series of parallel lines, if necessary, would be horizontal.

3

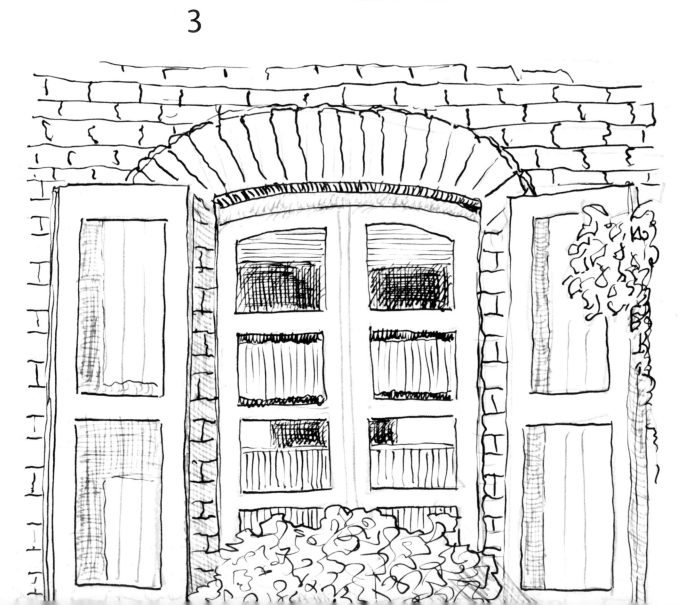

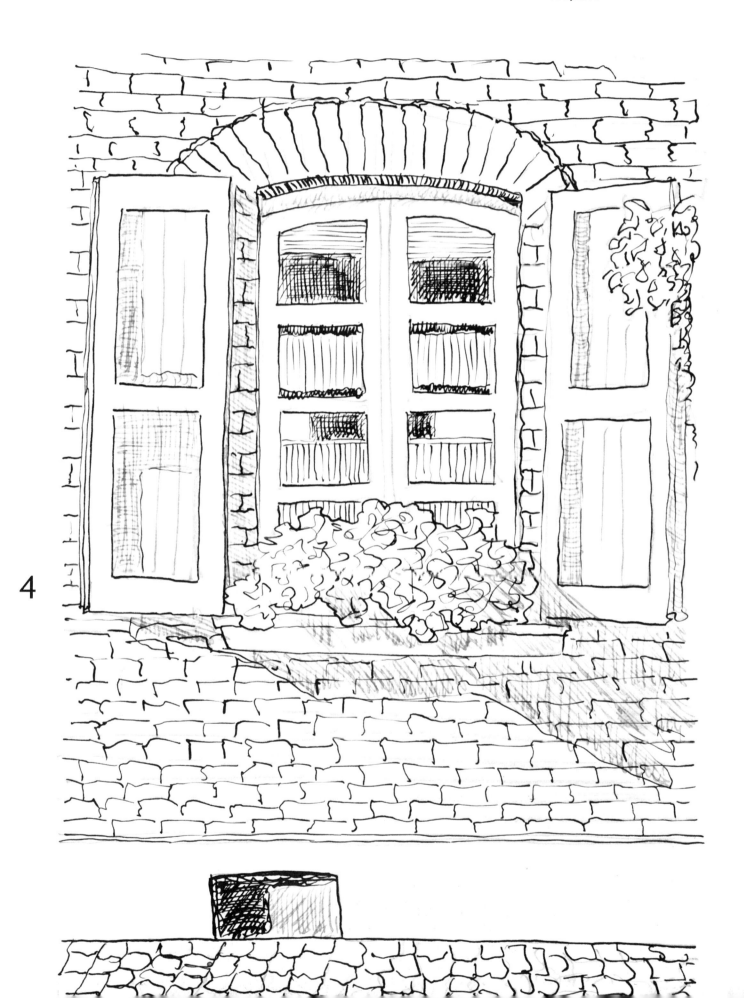

4

Close-up in Oblique View

In this exercise, you will draw two regular objects with flat surfaces, depicted in oblique view. Each object is in a distinct position; however, as they are aligned with each other, their position follows the same two vanishing points. This close-up conveys a couple of details quite well. It makes it apparent that everything that is closer to the viewer looks larger in all directions. In addition, the extreme close-up allows you to clearly see the different tones and highlights; for this reason, graphite pencil shading will give it rich nuances.

▲ Using pencils of various hardnesses will help you obtain a broad tonal range for depth and contrast. You will also be able to create an assortment of very light shades, which will be very useful for this drawing.

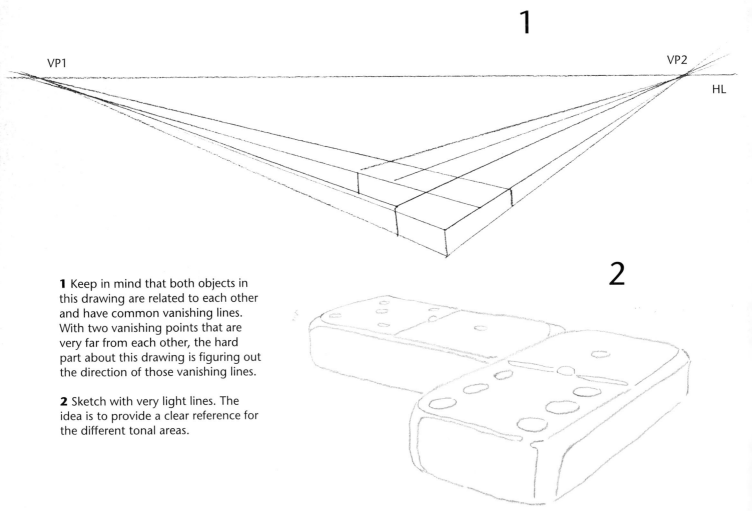

1 Keep in mind that both objects in this drawing are related to each other and have common vanishing lines. With two vanishing points that are very far from each other, the hard part about this drawing is figuring out the direction of those vanishing lines.

2 Sketch with very light lines. The idea is to provide a clear reference for the different tonal areas.

3 To shade the drawing, first locate the lightest highlights and leave them blank, being careful not to smudge the paper over these bright areas. Progressively add darker and darker values, paying special attention to the darkest areas that will create a strong contrast.

3

Tip
To establish greater depth, use shading to represent the cast shadows on the surface of the table and the images reflected on it.

DO	DON'T
Make sure the drawing, including the depressions on the dominos, clearly shows the direction of the light and shadow.	Draw all the depressions in the same size. The closest one should be drawn the largest, and they should get smaller the farther away you go.

Row of Houses in Perspective

Framing is one of the most interesting aspects of a drawing. Proper framing can turn a colorful drawing into an extremely attractive work of art. However, it's a good idea to set aside the idea of framing for a bit and first locate the direction of the lines for establishing perspective in the basic sketch. In this example with an oblique view, the sketch first develops the vanishing lines that head toward the vanishing point; once they are established, the scene is then framed. The combination of the vanishing lines and frame will allow you to confidently draw the essential lines and then color in the drawing.

A Divide the sketch into three parts, just as you did in the previous examples.

B Now, using vertical lines, divide the space up, keeping in mind that the closer something is, the wider it is, and the width of objects decreases as they get farther away.

C The peak of the roof is off-center, following the rule that the closer something is, the larger it is. Draw the remaining lines so that they converge on the second vanishing point, which is far to the right. Do not draw these lines horizontally. The blue frame then shows how to frame your drawing.

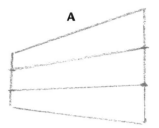

A

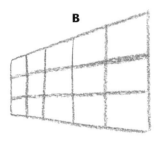

B

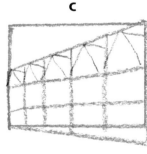

C

Tip

Always draw the first strokes lightly to easily correct them without smudging the paper.

◄ When you are drawing with a lot of pressure, it's a good idea to hold the paper down to keep it from moving around. Painter's tape is a good way to do this, as it allows you to frame your drawing and keep the frame defined with perfect, straight lines.

1 Draw the sketch with just a few lines, using a gray-colored pastel pencil. The first strokes should always be light to easily correct them, if necessary. Color the sky; make it more intense on the top, and lighter on the bottom.

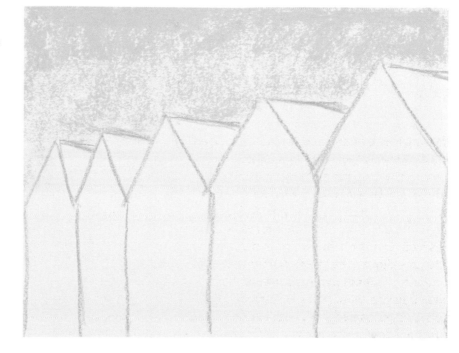

2 Color each door, making each one narrower the farther away they get. You can break pastels apart to more easily color certain hard-to-reach areas.

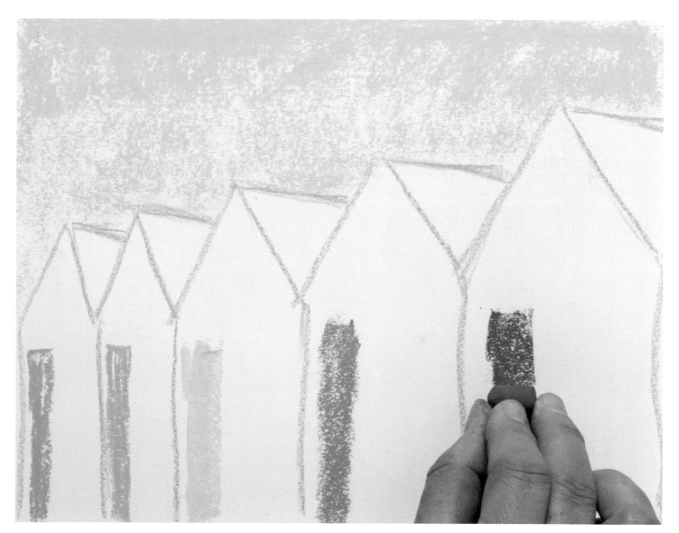

3

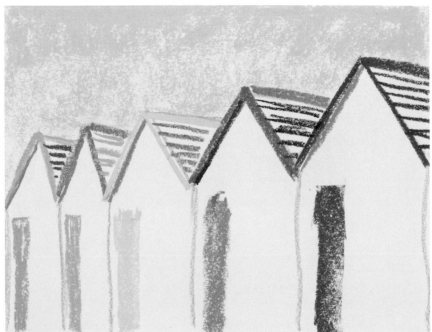

Coloring technique

With clever framing and vibrant pastels, you will be able to create a very colorful, attractive drawing. The sketch divides the space up into specific areas, and each area, drawn with a different color, creates a lovely visual contrast.

4

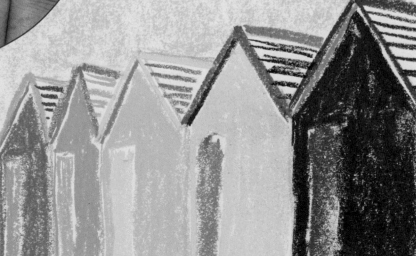

3 These details create texture on the roofs and begin adding color to the drawing. There are very few lines, but they are very descriptive.

4 Fill in the color using vertical strokes.

5

5 Apply a specific color of pastel to each space. Avoid smudging the adjacent space so you don't accidentally mix the wrong colors.

6 Use the tip of your finger to create a fading effect in the sky, using a soft circular motion. To emphasize the colors of the roofs, apply a light layer of the same color, using it to represent texture.

7 Use the tip of your finger again to blend the color inside each space, pressing down and smudging the color. Between each one, clean your finger with a cotton cloth to avoid smudging the other colors.

6

DO	DON'T
⬆	⬇

Make sure the line details on the roofs are slanted in the right direction.

Lose sight of the vanishing line that aligns the tops of all the doors.

7

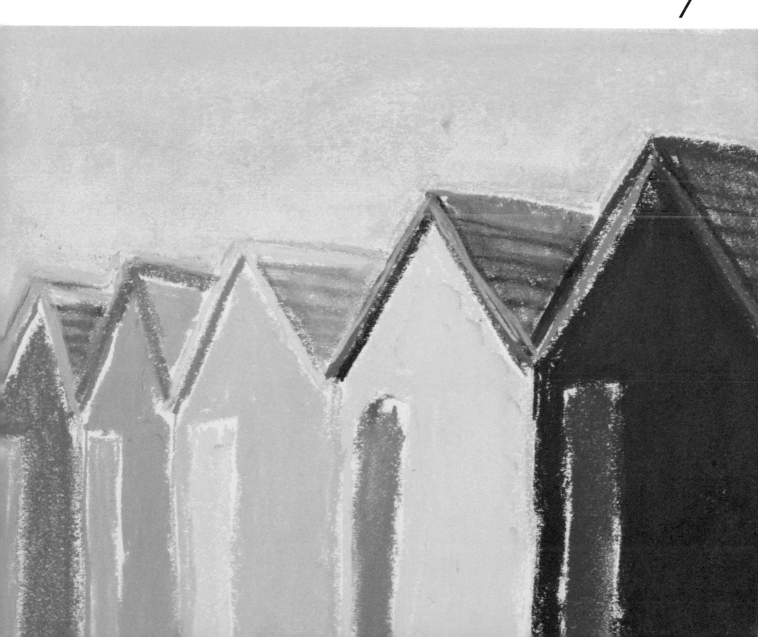

Bridge with One-point Perspective

In open spaces, perspective tends to be quite simple. The divisions among the different areas in the drawing are very apparent in this example. You can draw the elements of the structure in the foreground, with a frontal view, once you locate the vanishing point. Some of these elements and details, including the shadows they cast, will increase the sense of depth in the drawing. The background is also quite easy to draw. Use ink for this example, as your brush will allow you to introduce light values to represent the background, and your pen nib is perfect for constructing the lines of the bridge in the foreground.

1 The basic sketch is simple. Divide the space into various segments. The plane in the background will occupy a bit more than half of the paper. Distinguish the sky, a line of vegetation, the reflection in the water, and the entire foreground, including the bridge.

1

2 In the basic sketch, use the vanishing point to draw the rails of the bridge and establish the spaces with vertical lines.

2

DO ⬆

Make sure the cast shadows have a shape that reflects the object casting them.

DON'T ⬇

Make the background look too specific.

3 Work along the planes in the drawing, beginning with the farthest plane of the background. Lightly smudge the sky to represent how far away the clouds are. Shade the line of vegetation, clearly horizontal, with patches and outlines; however, draw them even more lightly in their reflection in the water. Establish the different sections of the bridge with vertical strokes that describe their shapes, using a one-point perspective. To create a sense of depth, smudge the drawing to represent the shadows of the clouds. Try to create a more pronounced contrast in the foreground.

▲ India ink lets you create great contrast on colored paper. Use your pen nib for outlines and your brush for diluted washes. Apply patches of color directly, or follow the wet-on-dry technique; in other words, once the first layer is dry, add a second coat on top. The tonal range will become more and more rich as you apply pen nib strokes and brushstrokes.

3

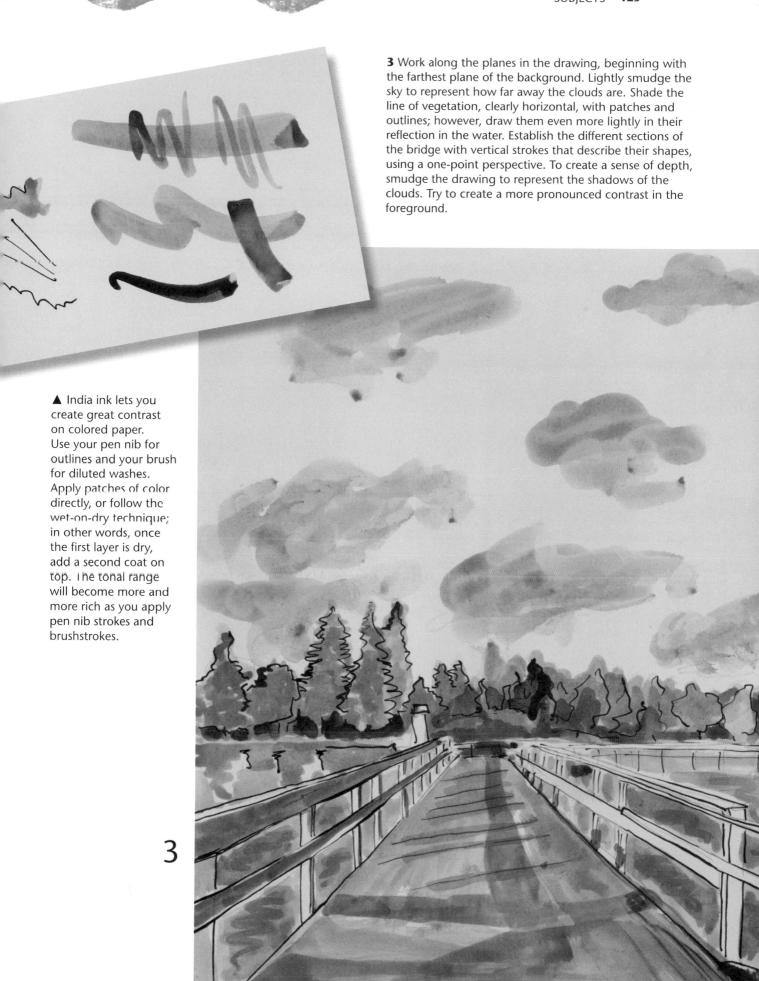

The basic sketch for this oblique perspective is quite easy to draw. Divide the protruding edge of the chalet into three sections, and partition off the rest of the drawing. Each group of vanishing lines should converge on their corresponding vanishing points. Once you place the roof, it is very easy to draw the rest of the general lines of the sketch on a sheet of colored paper with a charcoal stick. Using white chalk to emphasize the highlights and lightest areas will reinforce the charcoal and give your drawing an elegant look.

1 Draw the basic sketch, as well as the dividing lines to represent each section: the roof, the visible part of the chalet's wall, and the area where the railing is located.

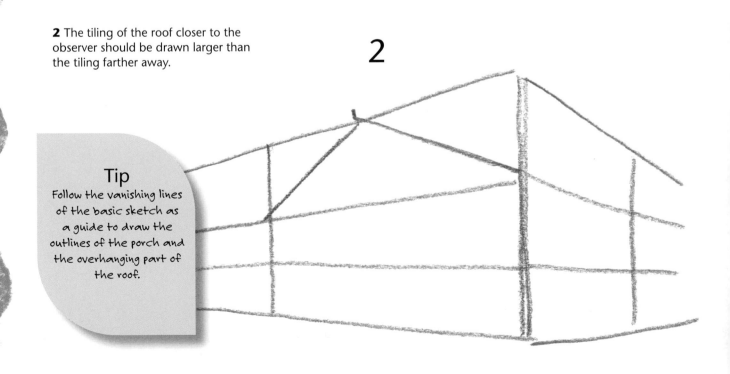

1

Chalet in Perspective

2 The tiling of the roof closer to the observer should be drawn larger than the tiling farther away.

2

Tip
Follow the vanishing lines of the basic sketch as a guide to draw the outlines of the porch and the overhanging part of the roof.

3 Sketch a few strokes that complete the sketch, and a few details to specify the setting of the chalet.

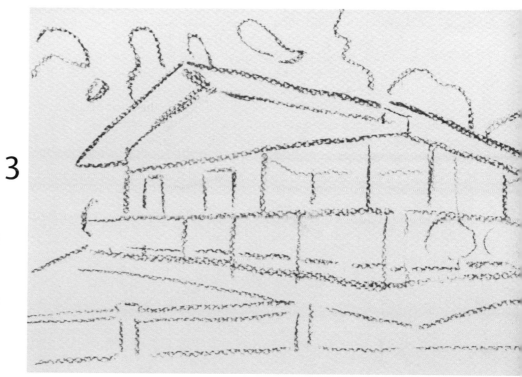

3

4 Now, move on to the background and the foreground; in other words, everything that surrounds the chalet. The shadow that begins under the chalet should be the most pronounced.

4

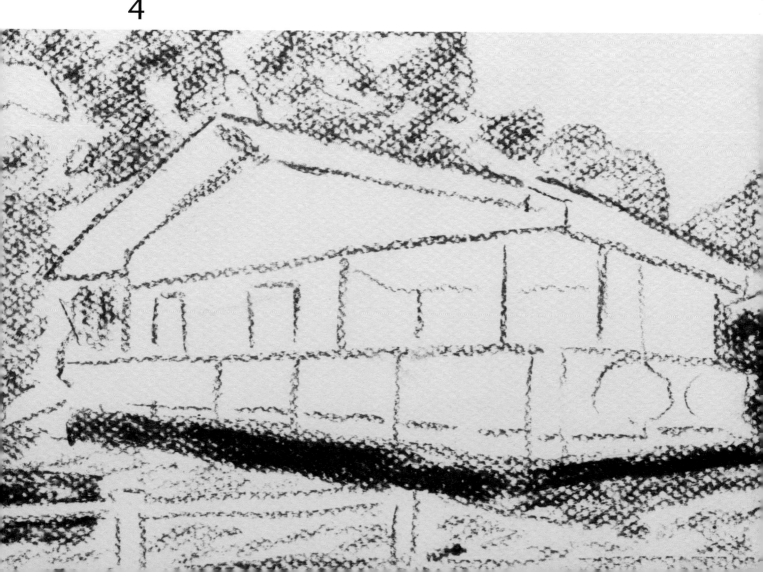

The best contrast

When you shade a drawing, you must use a tonal range. The most intense values are applied to the darkest shaded areas. The brightest areas, on the other hand, are represented with strokes of white chalk or with the blank of the paper. For the rest of the drawing, use intermediate tones, but always follow this rule: the closer the object is, the greater the contrast; the farther it is, the less the contrast.

5

5 The function of fading and smudging is to soften the shadows and give more realism to the background.

6 When shading the chalet, pay attention to the shadow of the roof tiling and try to create the right contrast to represent the entry to the porch.

Tip
Place a light bulb over the vegetation in the planters on the porch. The light should come from above and to the left of the planter.

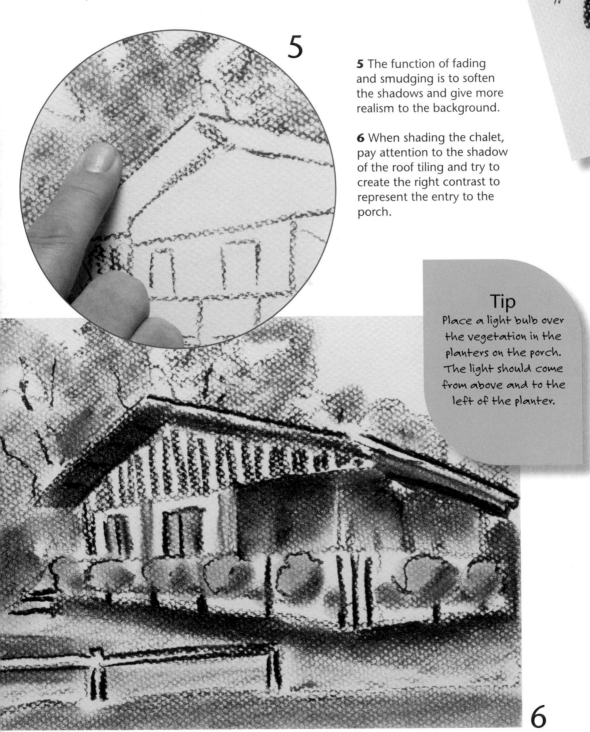

6

◄ When drawing on colored paper, charcoal sticks allow you to obtain strong contrasts, dulled in places with smudging and fading, with additional highlights in white chalk.

7 Some white chalk strokes help fade the charcoal. Others, applied directly to the paper, represent the brightest parts of the subject. The color of the paper represents yet another less bright shade of light.

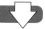

DO

Leave some areas of the drawing blank without shading them, to represent the brightest parts.

DON'T

Draw the trunks of the trees in the background with outlines that are too strong.

7

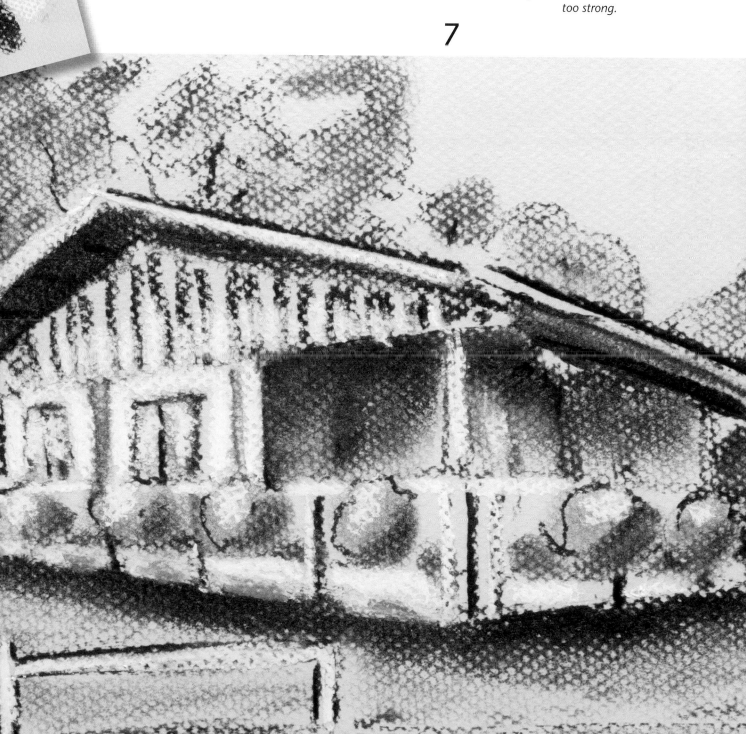

Perspective for the Beginning Artist

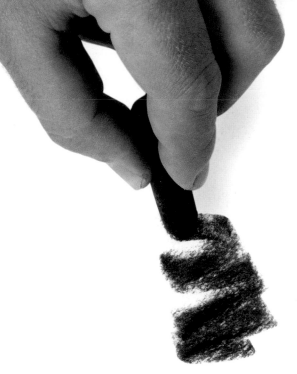

Dibujo de Perspectiva
© 2015 Parramón Paidotribo—World Rights
Published by Parramón Paidotribo, S.L.
Badalona, Spain

Design and production:
Parramón Paidotribo

Editorial Manager:
María Fernanda Canal

Editing:
Mª Carmen Ramos

Text:
Mercedes Braunstein

Drawings:
Mercedes Braunstein

Design:
Josep Guasch

Text and Page Layout:
Estudi Guasch, S.L.

Photographs:
Nos & soto

Production:
Sagrafic, S.L.

Pre-Printing:
iScriptat

6 Orchard Road, Suite 100
Lake Forest, CA 92630
quartoknows.com
Visit our blogs @quartoknows.com

Printed in Spain
1 3 5 7 9 10 8 6 4 2